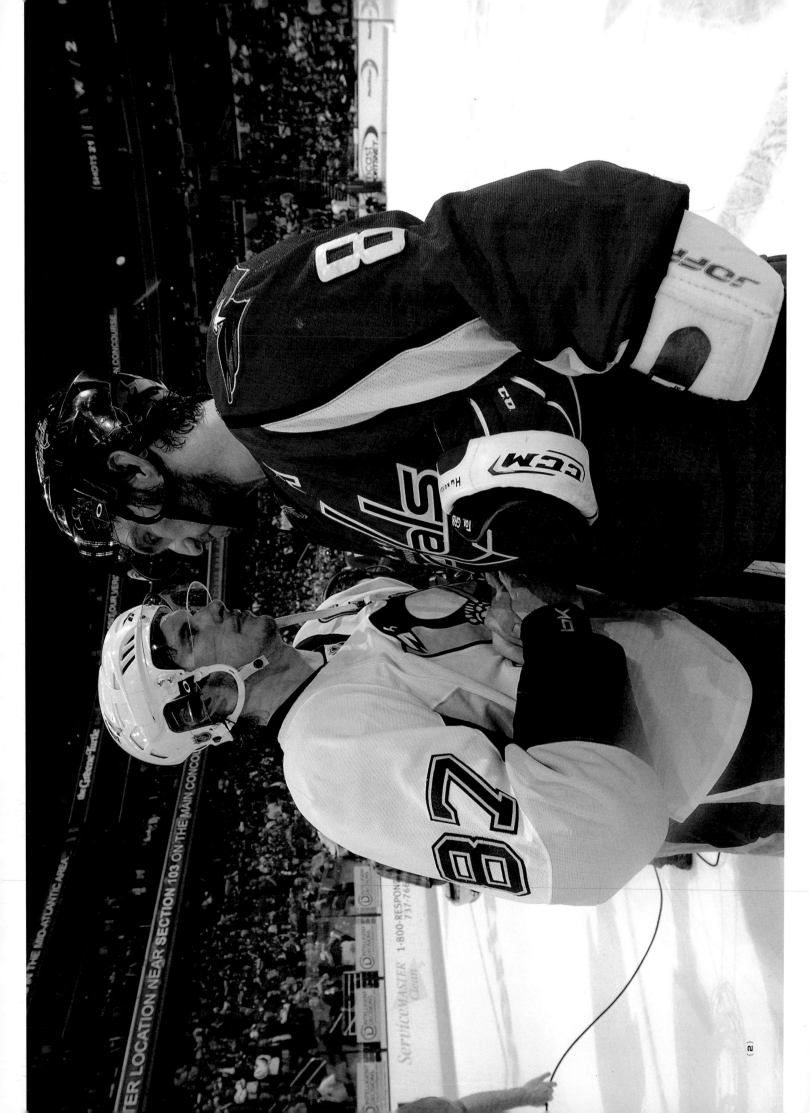

BEST OF THE DECADE

REFLECTIONS OF HOCKEY'S PAST TEN YEARS

FOR THE BENEFIT OF

HOCKEY FIGHTS CANCER

text by **MICHAEL A. BERGER**

foreword by **BRENDAN SHANAHAN**

presented by the **NATIONAL HOCKEY LEAGUE** and the

NATIONAL HOCKEY LEAGUE PLAYERS' ASSOCIATION

in conjunction with **NHL IMAGES** and **GETTY IMAGES**

GREYSTONE BOOKS

D&M PUBLISHERS INC.

Vancouver/Toronto/Berkeley

Greystone Books
An imprint of D&M Publishers Inc.
2323 Quebec Street, Suite 201
Vancouver BC Canada V5T 4S7
www.greystonebooks.com

Cataloguing data available from Library and Archives Canada
ISBN 978-1-55365-576-3 (pbk.)

Editing by Derek Fairbridge
Cover design by Peter Cocking and Naomi MacDougall
Interior design by Heather Pringle
Front cover images © Getty Images
From left: Len Redkoles; G. Flume; A.J. Messier; Dave Reginek;
Bruce Bennett; Jeff Vinnick; Richard Wolowicz
Back cover images © Getty Images
From left: Bruce Bennett; Elsa; Gregory Shamus; Gregory Shamus;
Bill Wippert; Jim McIsaac; Ronald Martinez
For a complete list of interior photo credits, see p. 173
Printed and bound in Canada by Friesens
Text printed on acid-free paper
Distributed in the U.S. by Publishers Group West

We gratefully acknowledge the financial support of the Canada Council for the Arts, the British Columbia Arts Council, the Province of British Columbia through the Book Publishing Tax Credit, and the Government of Canada through the Canada Book Fund for our publishing activities.

Mixed Sources
Cert no. SW-COC-001271
© 1996 FSC
FSC

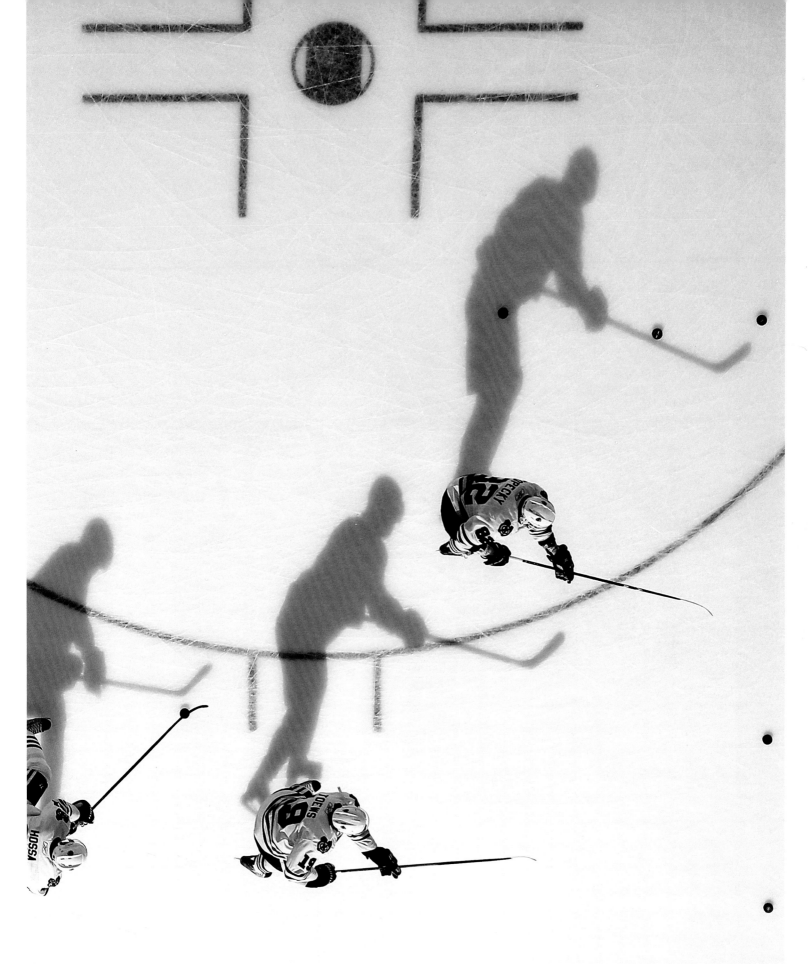

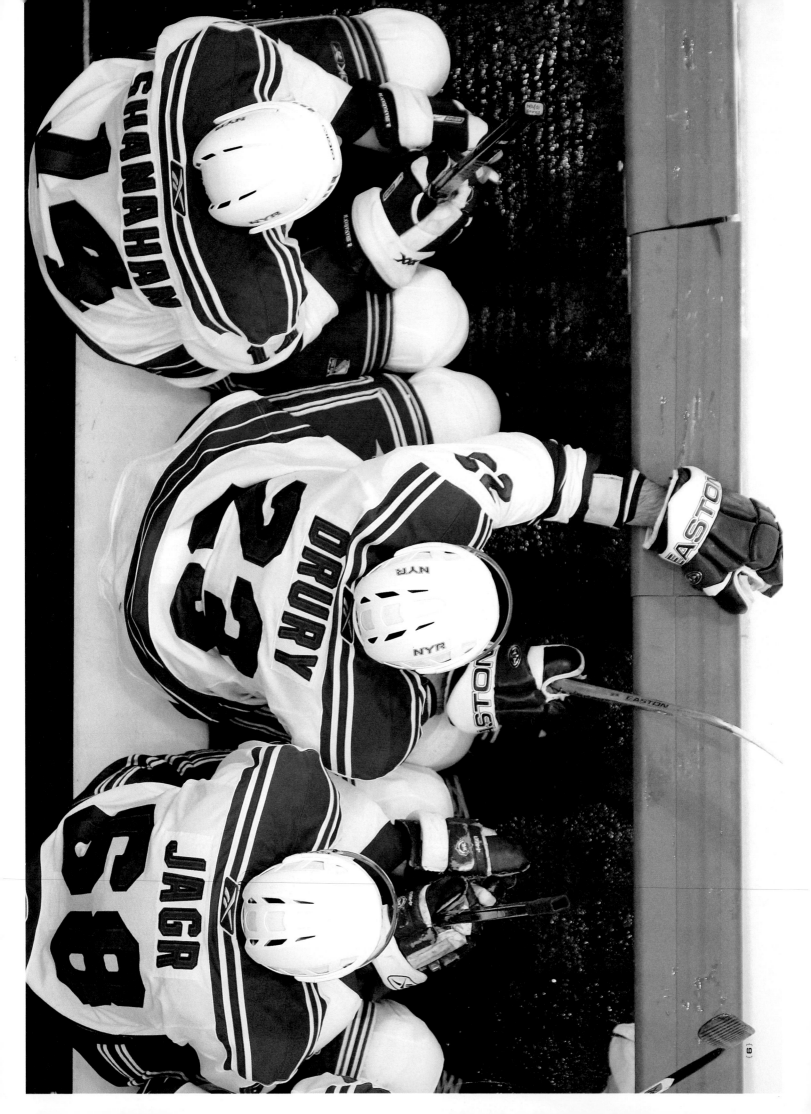

WHEN I LOOK back on the last 10 years of NHL hockey, the first word that comes to mind is change. The NHL has transformed itself both on and off the ice. This was a decade in which the game received a tremendous makeover. Hockey returned to its roots—the speed, the skill, and the excitement of the attack all were elevated.

The new rules introduced prior to the 2005–06 season were successfully implemented into the NHL and adopted by professional and amateur leagues around the world. Tougher standards on hooking, holding, and interference comprise the centrepiece of a rules package that aims to reward skill, speed, and smarts. Breakaway-producing two-line passes are in. Goalies playing the puck in their corners and tie games are out. The addition of the shootout means every game has a winner and a loser.

We couldn't talk about this decade and not mention the cancelled season of 2004–05. What was gained from this? Now the NHL has cost certainty. While there are pros and cons to any collective bargaining agreement, one thing is certain: the playing field for all markets has been levelled substantially. A salary cap now means the best players must be shared around the League and that any market, regardless of its size or wealth, has an equal opportunity to challenge for the Stanley Cup.

The game became even more global. Hockey players from anywhere can be power forwards, bruising defensemen, or smooth-skating, stickhandling wizards. In the past, you'd watch a player skate, stick-handle, or bang bodies and have a pretty good idea of what hockey system he grew up in. Now the lines have blurred and players and the roles that they play are decided solely by what they do on the ice and not the culture in which they were trained.

The last decade saw many great players of their generation retire and hand the game over to a new crop of players. Mario Lemieux, Steve Yzerman, Scott Stevens, Mark Messier, Patrick Roy, Brett Hull, Joe Sakic, and Ray Bourque stepped aside and a new generation of elite players like Sidney Crosby, Alex Ovechkin, Zach Parise, Patrick Kane, Jonathan Toews, and Drew Doughty, among others, have emerged and taken the NHL and its new rules by storm. What's interesting is that while these players possess many of the same gifts the Lemieux generation did, the depth of skill throughout the lineup, as well as advancements in coaching, scouting, and especially goaltending have evolved the game to the point where a superstar can still lead his team but isn't relied upon to carry it.

It's been a great decade, and with all these talented young players (and more on the way) coming into their own, I cannot wait to see what the next 10 years bring.

S O, 10 YEARS ago. Where were we then? What were our cultural touchstones, and just how far—if at all—have we come since? Think back 10-plus years to what we, from here on out, will be calling the last decade.

Clearly, technology and how we use it has made tremendous strides, has changed by orders of magnitude, at least to those of us who consume it and use it on a minute-by-minute basis to swallow information. Can you even conceive now of no text messages, no iTunes, no Google? Of no NHL.com?

But what if the question becomes not only, "what have we seen in the last decade," but also, "what have we felt?" If, instead of trying to form an inventory of this specific date and that particular action—that this happened, and then this happened—we instead allowed our memories to overwhelm us and reveal their stories, to provide the images we treasure, so that the patterns emerge. That is the journey we'll undertake in this book you hold, both in words but mostly in pictures—and, take my word for it, thankfully so. For if a picture's worth a thousand words, you'd be struggling through the equivalent of *A Tale of Two Cities*. Instead, you can merely turn the pages to see and experience the National Hockey League's last decade relived.

THE END IS THE BEGINNING

IN THE AUTUMN OF 1999, the NHL found itself at a crossroads, for it was the first time in 20 years that Wayne Gretzky did not dress for a member club. "The Great One"—maybe the game's greatest one ever—called it quits following the 1998–99 season, a season of disappointing proportions for a player of his magnificence, a season in which he scored but nine goals in 70 games—the worst of his career.

Wayne's absence served as the signpost at that NHL crossroads, if not necessarily the marker for the prevailing direction. For still playing were players like Mark Messier, Steve Yzerman, Patrick Roy, Ray Bourque, Brett Hull, Ron Francis, Luc Robitaille, Brendan Shanahan, and Brian Leetch. And if that group represented the old guard, relative youngsters like Martin Brodeur, Pavel Bure, Mark Recchi, Nicklas Lidstrom, Eric Lindros, and Jaromir Jagr stood poised to fill the generation gap.

Given what's occurred in the NHL these last 10 years, it would be difficult to imagine any other decade in the League's nearly century-long existence as exciting, as dynamic, as turbulent—both positively and negatively—as these last 10 years have been.

So perhaps by any measure, the years from 1999 through 2010 have been the NHL's best decade in its last 40. Not since the expansion that doubled the League in 1967 has the game been as accessible, as enjoyable, and as impressive as it is today.

How did we get here? What changes occurred that allowed hockey to grow from a stubbornly regional game into a game truly spanning the continent? How has it moved from a sometimes plodding past into its space-age, hyperdrive present?

You could take Gretzky's retirement as a signpost of another kind. By the time he retired, Gretzky had four seasons where he scored 200-plus points; he alone had created more than 200 goals of offense

for his team in each of those seasons. Yet in his final NHL season, just one team could manage as many as 250 goals (the 1998–99 Toronto Maple Leafs, who led the NHL with 268 goals).

And in the first season following The Great One's farewell, just two teams—the New Jersey Devils and the Detroit Red Wings—scored more than 250 goals. The NHL, you might say, was suffering a power shortage of its own.

In the decade to come, although their roots had already been planted, the Devils and Red Wings would become the NHL's standard bearers for excellence. Each had won at least one Stanley Cup championship by 1999, and each would win at least one more afterward. But before then, the NHL would expand its footprint into the American South and Midwest, opening new doors to novice fans in some places while rejoining some long-lost family members in others.

EXPANSION AND REGIONAL REBIRTH

DURING THE STORIED AGE of the Golden Jet's flair and the Rocket's red glare—that is, from 1942 through 1967—the NHL was a six-team league. In 1967, the League doubled in size and by 1979 had nearly doubled again—growing from a half-dozen teams connected by rail into a 21-team, continent-wide behemoth fully accessible only by air.

One of the six new teams welcomed into the fraternity in 1967 was the Minnesota North Stars, who would go on to represent big-league hockey in the Twin Cities for nearly 25 years. Five seasons later, the Stars were joined by—among others—the Atlanta Flames, giving the NHL its southernmost member club.

Unfortunately, North Star or Song of the South, the results for these member clubs—although separated by years—were exactly the same. The Flames left home first, decamping for Calgary a mere eight years into their NHL life. The Stars, meanwhile, moved to Dallas in 1993.

NHL hockey would return to Atlanta in 1999, nearly two decades after leaving. Preceded into the American South by the Tampa Bay Lightning and Florida Panthers earlier in the 1990s and the transfer of the Hartford Whalers to Carolina in 1997, Atlanta's new franchise, the Thrashers, debuted October 2, 1999, losing 4–1 at home to the New Jersey Devils. Kelly Buchberger scored the franchise's first goal and goalie Damian Rhodes took the loss. Rhodes and the Thrashers got their first win three games later, defeating the New York Islanders 2–0. Of course that was only natural—way back when, on October 7, 1972, Atlanta's Flames got their first win by also beating the Islanders, that time 3–2.

While the world's fastest game rose again in the non-traditional South, the NHL prepared for an encore in both the hockey hotbed of Minnesota's Twin Cities and in Ohio—an expansion that would bring the League to its present 30-team membership.

In 2000, the NHL welcomed both the Minnesota Wild and the Columbus Blue Jackets into the major league hockey fraternity. The Wild's birth fulfilled the NHL's promised return to the State of Hockey, the Land of 10,000 Lakes, after it allowed the Stars to migrate to Dallas. The public's reaction since the Wild's debut underlines Minnesota's love of the game; every one of the team's more than 400 home games since its NHL arrival has been sold out.

NHL hockey in Ohio was also a return, but few likely remember how or why. In 1976, the California Golden Seals (born as just the California Seals as one of Minnesota's 1967 expansion brothers) moved to Cleveland and became the Barons. By 1978, they were gone, merged with the Minnesota North Stars, but a generation later, the arrival of the Columbus Blue Jackets reintroduced the NHL to the Buckeye State.

Unlike their 1970s counterparts, the Blue Jackets are brimming with talent. Start with left wing Rick Nash, the first-overall pick in the 2002 NHL Entry Draft and the 2004 co-winner of the Maurice

"Rocket" Richard Trophy as the NHL's top goal scorer, and then add goaltender Steve Mason, who received 121 of 132 first-place votes en route to winning the 2009 Calder Memorial Trophy winner as rookie of the year.

ADAPTATION AND CHANGE

FROM 1961, WHEN THE Chicago Blackhawks won their last Stanley Cup, until 1997 when the Detroit Red Wings won their first in 42 years, no Midwestern team won the NHL's championship—collectively, a century's-plus futility. The Red Wings' 1997 championship changed that, much as their subsequent success changed the NHL itself, both before and after the League's lost season of 2004–05.

Arguably the first to embrace fully hockey's global impact, the Wings used their superb Old World scouting staff to supply one star after another who came of age through our decade in question: Pavel Datsyuk, Henrik Zetterberg, Johan Franzen—all flashy cogs on a team that, in the early part of our favourite 10 years, was more black and blue than anything else. The Kris Drapers and Darren McCartys, Kirk Maltbys and Brendan Shanahans, were the ground-and-pound physical shock troops first over the wall in the Y2K days, but when the NHL revamped its rule book to emphasize skill mid-decade, the European contingent became Detroit's primary offensive weapon. That skill message was not lost on Detroit's rivals as this decade wore on, finding its most fertile ground with the Wings' longtime—but mostly long-suffering—nemesis, the Chicago Blackhawks.

Following his father Bill's death in autumn 2007, Rocky Wirtz assumed command of the moribund Blackhawks franchise. He immediately revived it—and its long-suffering fan base—through a series of moves both on-ice and off.

He embraced former Blackhawks legends like Bobby Hull and Tony Esposito as team ambassadors, but symbolically his most important move was allowing the broadcast of Hawks home games, something his father refused for decades to permit. Where the elder Wirtz feared TV would cannibalize his season-ticket base, the son knew intuitively that TV promoted the game to a vast universe of potential customers.

As every hockey fan knows by now, those drastic changes led to a dramatic climax in June, with the Blackhawks winning the Stanley Cup. Almost naturally, Jonathan Toews captured the Conn Smythe Trophy as playoff MVP for leading Chicago to its first title in 49 years, while Duncan Keith put a period at the end of the sentence by winning the Norris Memorial Trophy as 2009–10's best defenseman.

And what of the rest of the Original Six? Having discussed Detroit and Chicago, how have the New York Rangers, Boston Bruins, Toronto Maple Leafs, and Montreal Canadiens fared these last 10 years?

The most celebrated franchise in hockey—and arguably in North American sports—the Canadiens commemorated their 100th anniversary through a yearlong series of ceremonies and salutes in 2008 and 2009. Perhaps not coincidentally, the Canadiens saved their best for the season of their 100th birthday. After winning the division in 2008, they marched to the Conference Finals in 2008, heavily favoured Washington Capitals and then Pittsburgh Penguins before falling to the Philadelphia Flyers.

In Toronto, a similar reawakening may not be far away. Upon his hiring in November 2008 as the Maple Leafs general manager, Brian Burke introduced himself to Leaf faithful by saying, "We require, as a team, proper levels of pugnacity, testosterone, truculence, and belligerence." That may be the best hockey quote of all time, perhaps second only to, "If you can't beat 'em in the alley, you can't beat 'em on the ice."

Now, success may not have immediately followed, but Burke's record says it can't be far away. He was a significant member of the front office that shaped the Vancouver Canucks team that reached the 1994 Stanley Cup Final, and he led the Anaheim Ducks to the

2007 Stanley Cup championship. The arrival of spit-in-your-eye defenseman Dion Phaneuf to serve as the Leafs' linchpin—and now, captain—highlights the changes Burke has made to Toronto's roster.

There are those who might argue not all of Burke's changes have worked. While Burke added Phil Kessel, who scored 30 goals for the Leafs in 2009–10, the resurgent Boston Bruins were the beneficiaries of Burke's largesse in that deal, and the B's ability to select Tyler Seguin with what would have been Toronto's pick at second overall in the 2010 Entry Draft will accelerate Boston's development for years to come. And given the emergence of players like goaltender Tuukka Rask, and the dominance of defenseman Zdeno Chara, the hub of Boston hockey will be buzzing for years to come.

If there was a player who served as the NHL bridge between the nineties and the aughts, who tied together the go-go era of the high-scoring Oilers and Penguins, through the years of the grind-it-out Devils, and into today's high-skill epoch, Jaromir Jagr was that player. Jagr led the NHL in scoring five times in his career, including twice in our decade in review, and as a New York Ranger Jagr demonstrated what today's game is about—and what it could have been through the earlier part of his career.

Backed by the NHL's zero tolerance for interference coming out of the 2004–05 lockout, Jagr set Ranger team records for goals in a season with 54, and points in a season with 123. Jagr finished second in scoring that 2005–06 season, and second in MVP voting (losing both times to San Jose's Joe Thornton). To record that kind of performance in the heart of the NHL's US media market proved the League's new intent to be a skill-driven operation.

The Rangers' roster throughout this decade proves general manager Glen Sather—dean of the Edmonton Oilers dynasty of the 1980s—never lost his need for speed and skill. He added Pavel Bure and Eric Lindros to a Blueshirts lineup already boasting Brian Leetch and Mark Messier, signed Jagr and Markus Naslund, then added Marian Gaborik in 2009. Sather was merely acknowledging the new reality, something his compatriots did—and would also do—as the decade proceeded.

SNOW GLOBE NOSTALGIA

GIVEN THAT SO MANY grew up playing the game outdoors, it's amazing the NHL took more than three-quarters of a century to rediscover its roots. For truly, what is more natural than an NHL game played in the elements?

The idea of playing NHL hockey outdoors first surfaced in 1990 when the Pittsburgh Penguins hosted the NHL's first All-Star weekend—the 41st All-Star Game and the first-ever Heroes of Hockey game and All-Star Skills Competition. No outdoor site was contemplated; instead, NHL organizers briefly considered opening the retractable stainless steel dome roof at Mellon Arena (then called Civic Arena), but passed on the idea to concentrate on perfect execution of the inaugural All-Star weekend. The following September, the Los Angeles Kings and New York Rangers faced off in a preseason outdoor game at Caesar's Palace in Las Vegas, but then the idea ground to a halt.

Ten years later, in 2001, Michigan State University hosted the University of Michigan at Spartan Stadium, a site better known—only known—for shoulder pads and cleats and football, and attracted more than 70,000 fans to kick-start the outdoor ethos once again and provide the NHL its eureka moment.

That inspiration led to the Heritage Classic at Edmonton's Commonwealth Stadium in November of 2003, the first regular-season NHL game ever played outdoors, and a 4–3 Montreal Canadiens victory over the hometown Oilers. Before the Habs-Oilers main event, Oilers and Canadiens alumni staged an exhibition game, after which Canadiens legend Guy Lafleur perfectly explained the event's magic by saying, "We felt like 10-year-olds out there."

Yes, exactly.

But while the event was an enormous hit, it would take another five seasons before the NHL would regularly schedule what has become the regular season's signature event, the Winter Classic. Featuring matchups between marquee teams and players in unique locations, and played on New Year's Day, the Winter Classic has elbowed its way into a crowded New Year's Day sports lineup.

Part of that success is attributable to the event's charm and singularity, the frosted players who are the boys of winter once again skating in the open-air of their youth (or, for an older generation that actually did most of its skating outside, of our youth) but often doing so on the playing fields of the boys of summer. The Chicago Blackhawks and Detroit Red Wings, clothed in the sweaters of their clubs' earliest days, colliding in front of Wrigley Field's storied ivy walls. Or the Boston Bruins and Philadelphia Flyers, two of the toughest teams of their day, batting each other around beneath Fenway Park's fabled "Green Monster."

The setting in Buffalo's Ralph Wilson Stadium was magnificent as well, and the game equalled its canvas. Hometown hero Ryan Miller, the Buffalo Sabres' goaltender, captured the spirit of the day—and reignited our own memories—by wearing a toque over his mask. The sapphire sky was reflected in the sweaters worn by the visiting Pittsburgh Penguins, glowing through the cold and grey winter light, and when it was time to head home, the game ended just as it always did: skater versus goaltender, one-on-one.

Just like when we were 10 years old.

RETURN AND REFOCUS

WHILE SOME ANALYSTS MAY parse the NHL season unplayed between 2004–05 in economic terms, the on-ice impact of that season-long impasse is far easier to assess, and it shows up in the

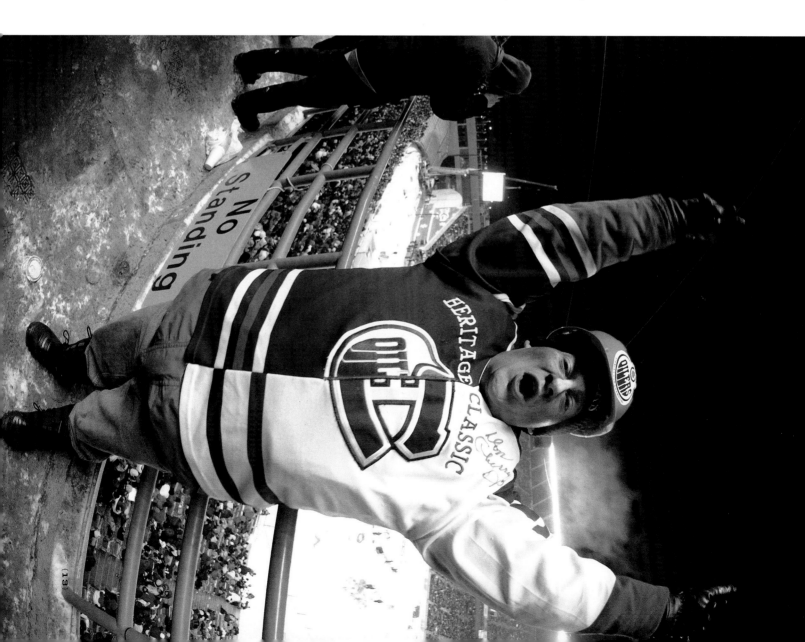

number of goals—and the way they are scored now versus then. But first, history.

In the 2003–04 season, the campaign prior to the cancelled year of 2004–05, the Ottawa Senators led the NHL by scoring 262 goals; in 2009–10, four teams scored more. More to the point, in that season prior to the work stoppage, 12 teams scored 200 goals or fewer. Last season? Not a single NHL team scored so few goals.

The catalyst? With the game needing a literal reset after a season away from the sport's fans, it was time to address any on-ice concerns that stifled the skills so necessary to play the game at the world's highest level—skills like skating, shooting, passing stifled because an emphasis on defense had overtaken the game's natural offensive flow.

Interestingly, perhaps ironically, that decade-long defensive emphasis came from the two teams you'd least expect—on paper, at least. It took the form of a strangling defensive-checking system commonly called the "neutral-zone trap," a system popularized by the New Jersey Devils as they struggled through the early part of the 1990s to both throttle their high-scoring division rivals and to emphasize their bedrock players: rock-solid Hall of Fame defensive defenseman Scott Stevens, and the man who would eventually hold nearly every goaltending record imaginable, Martin Brodeur.

In the other conference, the Detroit Red Wings adapted the trap into what they called the "left-wing lock." Now in reality, both defensive schemes were nothing new, essentially nothing more than a 1–2–2 forecheck that featured its defensemen holding the red line instead of dropping back as the attacking team came forward—or, tried to against a wall of defenders. What was so surprising, though, were the coaches who preached it for the teams that played it.

Both had their links to the fire-wagon hockey of the 1970s Montreal Canadiens dynasty; in fact, the coach of one played for the other. We're referring to Jacques Lemaire—who turned the rising New Jersey Devils into near-perennial Stanley Cup contenders—and to the old master, Scotty Bowman for the Detroit Red Wings. And of course, Lemaire played and starred for Bowman for *Les Habitants*.

The surprise continues when you consider that, in the six seasons between 1994 and 2000, the Devils and Red Wings each won two Cups and finished 10th and second respectively in goals scored during that time, so clearly each could have succeeded with the offenses they had. To stretch the question further, from the time of the first Cup won by either club (New Jersey in 1994–95) through the 2003–04 season prior to the lockout, the clubs finished first (Detroit) and ninth in goals-scored. So clearly, again, the teams had few scoring troubles even with a defensive orientation. We should also add that, not surprisingly, they finished first (New Jersey) and third in goals-against during the same period (not counting the League's expansion teams that didn't compete for the full span).

So despite the duo's clear offensive prowess, their defensive attitudes narrowed offensive tendencies across the NHL—especially so when you consider that pro sports teams copycat their champions regardless of league or game, and doubled again when the aforementioned expansion clubs (often limited in their depth of skill throughout their rosters) enter the picture.

Two league-leading teams playing superlative defense, compounded by contending teams imitating the champions, plus expansion seemed to have equalled offense shoved into the background; a case where less was definitely not more. *Et voila—le "dead puck" era.*

But what to do? Enter the competition committee created by NHL Commissioner Gary Bettman following the lockout to address the game itself, and featuring four players, four general managers, and one owner. From this group came a set of rules changes and recommendations that changed the NHL's defensive posture and restored its offensive emphasis.

Among other things, the group recommended removing the centre red line from two-line passes (allowing the offense to sneak behind the defense for long breakaway passes, potentially forcing the defense to back away from centre ice and toward its own blue line, and thus opening up centre ice for opposing forwards to skate through, hence neutralizing the neutral zone trap), reinstituting the "tag-up" off-side rule to keep the puck—and the game—moving, and limiting the area in which goaltenders may handle the puck.

At the same time, the NHL issued a new set of officiating priorities, chief of which was zero tolerance for interference, hooking, holding, and obstruction. And what was the result? In the 2005–06 season, the first following the lockout, seven players scored 100 or more points, two more than in the previous five seasons combined, and the highest total since the 1995–96 season when an even dozen players did so. In pre-lockout 2003–04, only the Ottawa Senators scored as many as 262 goals; in post-lockout 2005–06, nine clubs scored at least 262 goals and six clubs scored 280 goals or more.

Clearly, then, the breath of fresh air blown into the game following the lockout cleaned out the offensive cobwebs and returned the emphasis of skill (including hard-hitting bodychecking) to its rightful place on the game's stage.

But while an emphasis on skill can be legislated, the creation of the super-talented player, he who has skill cannot. The appearance of the super-talented player, he who has command of the game's facets and plays at the highest possible level, is nothing but providential. So how come in the NHL he always seems to have a rival?

A CLASSIC RIVALRY

CHOOSE ANY SET OF opposing pairs you like: hot and cold, calculating and emotional, fire and ice, yin and yang. They're the easy way to characterize superstars Sidney Crosby and Alexander Ovechkin, the

simple way without mistake, but those terms do no one any justice—certainly not the game, and least of all the players. First the tangibles, the easily defined things, the numbers:

Since he entered the League five years ago, no player has scored more goals than Alexander Ovechkin. Since he entered the League five years ago, no player has scored more points than Alexander Ovechkin. And since he entered the League five years ago, no player has generated more highlights, more pure thrill-a-moment excitement than Alexander Ovechkin.

Sidney Crosby, meanwhile, has merely become the youngest captain in NHL history, the youngest player to ever score 100 points in a single season, the youngest to win a season scoring championship, has already been named an MVP, and has earned both a Stanley Cup championship and an Olympic gold medal.

The NHL has long had opposing rivals, be they Gordie Howe and Maurice Richard decades ago, Wayne Gretzky and Mario Lemieux more recently, or "Sid the Kid" and "Alexander the Great" today. But there is something different about this pair. For one thing, the speed at which they play is unmatched—certainly today, and maybe in all of hockey history. These two turn the world's fastest game into their own personal *Matrix*, warping time and space around them. The similarities shared by Ovechkin and Crosby are startling. Each was the first pick in his respective draft, Ovechkin in 2004 and Crosby in 2005, yet because the aforementioned lockout forced Alex to postpone his NHL entry, they debuted together—co-first-overall picks as it were, as if uncannily birthed just for comparison.

Each captains his squad, Crosby since 2007 and Ovechkin since January 2010. They are first (Ovechkin) and third (Crosby) in points since entering the NHL in 2005–06, a nod to Ovechkin and his explosive goal-scoring abilities and a recognition of Crosby's play-making talents. Either might be the unanimous choice for starting a

franchise—no one else today, at any position, is so clearly dominating, so evidently extraordinary.

But while their statistical accomplishments are similar, their playing styles and attitudes are very different. You get the idea Crosby is more cerebral, seeing the game slowly unfold before him while he remains three steps ahead, whipping seeing-eye passes to ever-so-slightly stunned teammates who can't figure out—even on replay—how Crosby got to the puck and the puck got to them. His playmaking ability is stupefying, not seen since The Great One hung up his skates, and it is not for nothing that Gretzky himself nick-named Crosby "The Next One."

Whereas Ovechkin is more elemental, a whirling dervish cum Tasmanian Devil on skates, using all of his 6-foot-2, 235-pound frame to trample the opposition and power his remarkable game. Ovie is bigger than Gordie Howe or Mark Messier, and a better goal scorer than Eric Lindros or Cam Neely. He is a living physics lesson: force equals mass times acceleration. Crosby and Ovechkin differ in another way, separate from each other in a way completely connected to each man's own playing style and personality. Ovechkin would be perfectly at home choreographing goal celebrations with the NFL's Chad Ochocinco, flamboyant and spirited and unbridled—joyous in the accomplishment. Crosby is more refined, more reserved—no less joyous, just less demonstrative.

To compare careers just started instead of just ended seems premature. Awards are subjectively voted on, and championships are won by teams and not single players. Besides, who says every discussion must sound like talk radio? Must everything be a question of "who's better"? Can you choose between Picasso and Degas? Must you? Should you?

There is no question, though, that when facing one another they bring out the best in each other—just look at the Eastern Conference Semifinal between the teams which preceded Pittsburgh's 2009 Stanley Cup win: 13 points in seven games for Crosby; 14 for Ovechkin in the same.

And from that, for players who could have as much as 15 years apiece left on their careers, observers want to determine a "who's better" winner. Well, go ahead if you like—but we won't indulge. We will, however, eagerly anticipate another decade's worth of matchups, whether as riveting as that playoff series from a year ago or as quiet as the preliminary round game in the 2010 Olympic Games in Vancouver.

GLOBAL GLASNOST

ALTHOUGH THEIR GAMES DON'T fall into the typical stereotypes about styles—Canadian versus European—the towers of power that are Crosby and Ovechkin do serve as symbols of the NHL's international efforts this last decade, be it spreading the gospel overseas or welcoming an increasing European presence among the League's award winners.

Demographically, the NHL remains a resoundingly North American league. More than half its players are Canadian, and another fifth is born in the U.S. Together, Canadians and Americans comprised 75 percent of the League's players in 2009–10. The majority of the remaining 25 percent hails from Scandinavia and Eastern Europe, regions that have been contributing players to the NHL in abundance for decades.

What is different now, though, is the reciprocal effort the NHL puts forward to bring the game to its European fans. For the fourth straight season, the League is hosting overseas contests—all counting in the standings, with a record six clubs opening 2010–11 in Europe.

These games are just the latest step in the last decade's ongoing effort to bring the NHL to the world, with the Winter Olympics the primary promotional showcase. NHL players started playing in the

Olympics in 1998 at the Nagano Games (that is, the NHL suspended its season to allow players to represent their countries), and in 2010 the Winter Games were played in an NHL host city for the first time.

Truly, the international influence is ever-present in today's game. Four of the top 10 scorers this past year were from overseas, a fifth from the US and the remainder from Canada—not quite a mirror of the NHL's playing population demographic, but pretty close. Over the last decade, five Europeans have led the NHL in scoring, four Canadians.

Look at the winners of the Hart Memorial Trophy, naming the NHL's most valuable player, and you'll see nearly the same divide over the last decade—and nearly all the same names as your past Art Ross trophy winners as top scorer: Henrik Sedin, Crosby, Ovechkin, Joe Thornton, Martin St. Louis, Jaromir Jagr, and Peter Forsberg. Same essential proportions for the Vezina Trophy for the League's best goaltender; Canadian Martin Brodeur and Czech Dominik Hasek appear as often as expected, and for every Tim Thomas (US) there's a Miikka Kiprusoff (Finland).

About the only place where there's an imbalance in either direction is within the roster of Norris Memorial Trophy winners as the NHL's best defenseman, but that's because Nicklas Lidstrom has been so good for so long. Still, Lidstrom and Zdeno Chara on the European end are paralleled by Scott Niedermayer, Chris Pronger, and Al MacInnis from this side of the pond.

GREATS SAY GOODBYE

WE'VE BEEN NAME-DROPPING A lot of great players over the last few pages—some new, some old. So, let's take a moment to read the roll call of some of the greats of this game who've retired in the decade just passed: Brett Hull, Mario Lemieux, Luc Robitaille, Steve Yzerman, Scott Stevens, Mark Messier, Ron Francis, Al MacInnis, Eric Lindros, Brian Leetch, Jaromir Jagr, Joe Sakic. Has there ever been a list of luminaries to match this?

Look at Brett Hull and Luc Robitaille. On the surface, you couldn't find two more different players—Hull loud, where Robitaille is quiet. One is stocky—has even called himself "fat"—the other thin. One has a golden hockey pedigree, the other humble hockey beginnings. And yet by the ends of their careers, each was a Hall of Famer.

By the time he was finished, Luc Robitaille had scored more goals than any left wing ever. And Hull? Well, that apple didn't fall too far from the tree—but it did roll a good bit past it. Brett closed his 19-year NHL career with 741 goals, a total surpassed by only two players in all of the NHL's storied history: Wayne Gretzky and Gordie Howe. The "tree" in question is, of course, Brett's father, Bobby—hockey's "Golden Jet." Like his dad, who led the NHL in goals seven times, the younger Hull was also prolific. The "Golden Brett" strung together three straight seasons from 1989 through 1992 in which he scored 70-plus goals.

For 20 some odd years, across more than 2,600 games and scoring over 3,500 points between the two of them, the artistry and finesse of Ron Francis and Mario Lemieux often represented the play of a centre at its most elegant and its most potent. Each was a captain but it was only when they played together that they became Stanley Cup champions.

A third member of this group of elite centres played his entire career in Motor City, USA, beginning with a team that was then among the historically worst the NHL had ever seen, yet finished it a generation later by leading the Detroit Red Wings to three Stanley Cups.

Without the size of Lemieux, the guile of Gretzky, or the muscularity of Mark Messier, Steve Yzerman quickly made his presence felt for the Wings, pulling them along behind his quiet authority and self-sacrificing two-way play all the way from chumps to champs. Named

in 1986 the youngest team captain in club history, Yzerman retired two decades later as the longest-serving team captain in North American sports history. He scored a career-high 155 points in 1988–89; only Gretzky and Lemieux have ever scored more points in any single season.

With so many so good at his position of choice, it would be perhaps easy to overlook the classy Colorado Avalanche centre Joe Sakic. When your contemporaries are named Gretzky, Messier, Lemieux, Francis, and Yzerman, being overshadowed is an occupational hazard. Easy to overlook perhaps, wrong certainly. In the entire history of the NHL, only six other centres scored more career points than the elegant Sakic. "Elegant" is a term rarely heard in NHL circles. It brings to mind the play of men from eras past like Jean Béliveau and Jean Ratelle—also centres who excelled at playmaking and carried themselves with the same poise and class Sakic demonstrated. Sakic, in 20 NHL seasons, averaged just 30 penalty minutes a season while notching six 100-point seasons and two 50-goal campaigns, gaining three first team All-Star berths, twice winning the Stanley Cup, and earning Conn Smythe and Hart Memorial trophies in 1996 and 2001, respectively.

Sakic captained the Nordiques/Avalanche franchise for 17 years, a single-team accomplishment bested by just one of his generational counterparts, but here is a feat they—and perhaps no one—can equal: Joe Sakic scored eight playoff overtime goals in his career, two more than any man who has ever played NHL hockey.

Over much of the same time that this quartet of centres dominated NHL rinks, two of the most physical players the NHL has ever seen offered counterpoint to that foursome's silky smooth playmaking with an almost unprecedented crash-and-bash style.

Sixty years ago, Gordie Howe's nickname was "Power"; it was not until Mark Messier's debut that the NHL saw its next-generation of power forwards, as demonstrated by his combination of heart-stopping skill and speed combined with bruising and sometimes vicious physical play. "The Captain," as he came to be known, was the game's definitive leader, a fierce presence who was at once both the irresistible force and the immovable object while leading two separate teams to Stanley Cup victories. Only one man—Howe, who prefigured him as the game's most powerful figure—has ever played more games in an NHL career.

This was the example Eric Lindros was to follow, the path he was to bulldoze in bowling-ball style while physically dominating the NHL. It never quite worked out that way for the "Big E," whose physical style undermined his health. Lindros never played a full season in the NHL, coming closest in the 2002–03 season when he played 81 games. Certainly, when judged against any Hall of Fame career, durability is and should be a factor. But until the hits took their toll Lindros was among the greatest ever. Consider this: over the first seven seasons of his career, Lindros averaged 1.392 points per game. Among players who scored 500 or more points in their careers, only four other men were ever better: Wayne Gretzky, Mario Lemieux, Mike Bossy, and Bobby Orr. Use the same criteria over just the first four seasons of his career, and Lindros supplants even the great Bobby Orr, by averaging 1.457 points per game.

And who were the defensemen they faced, these offensive titans of the past decade? The men manning the blue line had styles as various as those boasted by the forwards they faced. Take American-born superstar defenseman Brian Leetch, he of the sublime puck-handling moves and record holder for most goals in a season by a rookie defenseman with 23. The same Leetch, teamed with Messier, led the New York Rangers to the Stanley Cup championship in 1994, collecting the Conn Smythe Trophy as playoff MVP in the process.

His figurative opposite would be longtime divisional rival Scott Stevens who, in a 22-season, three-team career may just have been the most physically imposing defenseman the League has ever seen. It is no accident that even now, a decade after levelling Eric Lindros

at centre ice during a Stanley Cup playoff game, that hit typifies both hardnosed hockey and Stevens at their best.

And then there was Al MacInnis and his booming slapshot, so feared in its time that few forwards were foolish enough to drop and try to block that shot from getting through to the goaltender. MacInnis was a star for two teams, first the Calgary Flames (winning a Stanley Cup in 1989 and earning Conn Smythe honors), before closing his career with the St. Louis Blues.

The one blueliner whose exemplary play best defines defensive greatness at both ends of the ice was Ray Bourque. Seen as the second coming of Orr in Boston, Bourque would go on to eclipse Bobby in both points scored and games played. Although lacking Orr's flair, it is Bourque who owns the record for most career goals by a defenseman, most career assists by a defenseman, and thus most career points by a defenseman.

And the last line of defense? How about Dominik Hasek, twice a Hart Trophy winner in the years just before our decade-of-interest began, and six times a Vezina winner, including twice within our specific decade?

Absolutely Martin Brodeur, holder of nearly every record for NHL goaltenders, will be on this list, and his tenure of excellence spans our decade, as well as prior and beyond. Let's quickly consider the measures of his excellence: most career shutouts by a goaltender; most games played by a goaltender; most career wins by a goaltender; Calder winner as the NHL's best rookie in 1994; four times a Vezina Trophy winner; and three times a Stanley Cup champion. On top of all that, Brodeur is one of just 10 goaltenders all-time to score a goal—and just one of two to do so in the playoffs (Ron Hextall is the other).

But most certainly Brodeur's inspiration—and the man responsible for revolutionizing the art of goaltending in the NHL—the man with the largest impact on this generation's netminders is Patrick Roy.

Emotional, flamboyant, possessed of great *savoir faire*, Roy was—as his name implies—the king of goaltenders from 1985 through the turn of the century and until his retirement in 2003. And those career records now in Brodeur's possession (achievements such as games played, wins, consecutive 30-win seasons) were almost all set prior by Roy. We might add, however, that the Stanley Cup playoffs still belong to Roy: most career playoff appearances, most career playoff shutouts (tied with Brodeur at 23), and most career playoff wins.

With a line of goaltending evolution tracing back to Glenn Hall and through Tony Esposito, Roy's butterfly style of goaltending became iconic in his native province of Quebec, and then much-adopted throughout today's NHL world. You can see his influence in players like Marc-André Fleury, Roberto Luongo, Henrik Lundqvist, Ryan Miller, and Brodeur himself.

But Patrick was one of a kind, whether standing up to Canadiens' management to demand a trade after his perceived mistreatment at the hands of the then-coach Mario Tremblay, winking at LA forward Tomas Sandstrom after robbing the Kings during the Stanley Cup Final of 1993, or trash-talking Chicago Blackhawks forward Jeremy Roenick, telling J.R. he couldn't hear his boasts because Stanley Cup rings were plugging up his ears.

STARS ASCENDING

SO THOSE ARE THE giants upon whose shoulders today's generation is standing, but who are those players carving their names into the ice today and for the next decade? Who are the successors to yesterday's stars?

Let's start with Sidney Crosby's Pittsburgh Penguins teammates, where Evgeni Malkin must surely rank as Crosby's first-among-equals. For some heretics, in fact, Malkin is even whispered as the more talented of the two. The duo is joined there by one of the four

Staal brothers, in this case super-talented Jordan, giving the Penguins strength down the middle for years to come since Malkin is the oldest of the trio at just 24 years old.

As for Jordan's brothers, oldest brother Eric has also won a Stanley Cup (Carolina, 2005–06), while middle brother Marc (the lone defenseman among the brood) has been a regular for the New York Rangers since being selected 12th overall in the 2005 Entry Draft. Meanwhile baby brother Jared, a promising right winger, finished the 2009–10 season playing in the American Hockey League.

Of course as brothers go, there is no better set today than the Sedins—Henrik and Daniel—currently starring for the Vancouver Canucks. The twins, selected second and third overall in 1999 courtesy of some draft wizardry by then general manager Brian Burke, have come into their own since the lockout, with Henrik leading the entire NHL in scoring in the decade's last season (becoming the Canucks' first-ever Hart Trophy winner in the process) and the pair finishing first and second in Canucks' scoring every season since 2006–07.

Proceed south from Vancouver along the Pacific coast to Hollywood, where you'll find two 20-something defensemen leading the youthful LA Kings on their charge up the standings. Drew Doughty and Jack Johnson, 20 and 23 years old, are two of the game's best young blueliners—supporting Slovenian centre Anze Kopitar.

Go from the Pacific to the Atlantic, or more accurately to the Gulf of Mexico, and you will find someone who has already—in just his second NHL season—raised himself into the League's elite. The NHL had three 50-goal scorers last season; two of them we've discussed in detail elsewhere. The third overcame a dreadful start to his NHL career, suffering benchings and extra workouts in his freshmen NHL year, to say nothing of front-office chaos and fired coaches. But since the closing days of February 2009 and through his sophomore season

of 2009–10 (that is to say, the last 18 months), the NHL has seen no better goal scorer than Tampa Bay's Steven Stamkos.

The first-overall draft choice in the 2008 Entry Draft, Stamkos entered the NHL as a solution—the answer to the problems suffered by the Lightning in the seasons following their 2004 Stanley Cup championship. Instead, early at least in his first year, Stamkos raised more questions than he answered, scoring just four goals in his first 41 games. But a light went on February 17, 2009, when he scored three times versus Chicago, and Stamkos has burned brightly ever since, recording his first 50-goal season at a younger age than players like Mario Lemieux, Mike Bossy, or Mark Messier.

But what if, rather than travelling south from Vancouver, we travel east instead—across the Canadian Rockies and into the heart of the Canadian west, and Calgary. There, for more than 1,000 games, Flames fans have watched the best player the franchise has ever seen set record after record after record.

While it's true Jarome Iginla is closer to the twilight of his career than to the dawn, he remains one of the best players in today's game, and the most prolific player in franchise history. Most career games played? Check. Most career goals scored? Check. Most career points scored? Check. Among the most consistent scorers of all time, Iginla's scored 30 goals in nine straight seasons.

Follow the trail of the Rockies down into the lower 48 and you'll

find a second-generation star following in his father's—and uncles'—footsteps, and doing so for the franchise where his elders made their biggest marks. It's a nice little bit of coincidence that Paul Stastny stars now for the same team that boasted his father Peter, and Paul's uncles Anton and Marian. That the elder Stastnys skated for the Quebec Nordiques, while the younger labours for the Colorado Avalanche is just that little bit of happy coincidence—for this team by any other name is still the same franchise. And though 24 years old,

Stastny has already turned into Colorado's old man, courtesy of the play of rookie youngster Matt Duchene, who finished third in scoring for the club in his first NHL season, and whose 55 points last season led all rookies in scoring.

A 2010 US Olympic teammate of Stastny's is also a second-generation NHL star and, like Stastny, leading his team offensively as well. Zach Parise has led the New Jersey Devils in points each of the last three seasons, performing so well that—like his father J.P. back in 1972 during hockey's legendary Summit Series—the youngster was chosen to represent his country in international competition, finishing tied for third in points in Vancouver's Olympic Games with Team USA teammate Brian Rafalski and Team Canada rival Jonathan Toews.

We've mentioned Toews and teammate Patrick Kane leading the Blackhawks rebirth in Chicago, just as we've mentioned Rick Nash in Columbus. We haven't mentioned two defensemen responsible for some offensive fireworks of their own, Washington's Mike Green and Shea Weber of the Nashville Predators. Green owns the NHL record for defensemen for most consecutive games with a goal (eight straight, to remind you—set two seasons ago), and over the last four seasons no defensemen has scored more goals than his 70.

In Nashville, according to the local scribes, the players have a saying: "Pass it to Shea and get out of the way." Weber's 62 goals trail only Washington's Green over that four-season span. And if we add a season to that calculation—meaning from 2005–06 until the decade's last season—we can place a third name at the top of that goal-scoring by defensemen list: Toronto's Dion Phaneuf leads all defensemen with 77 goals since the lockout, and he's also not afraid to mix it up. Phaneuf's 556 penalty minutes over the last five seasons is far and away the most by any blueliner with at least 100 points during that time. The best part about this threesome? Each is just 25 years old, meaning plenty more years of stardom.

And goalies? While the inestimable Martin Brodeur keeps on keeping on, he will—one day—stop playing. When that happens Ryan Miller from Buffalo, Roberto Luongo from Vancouver, Henrik Lundqvist from the New York Rangers, or Miikka Kiprusoff will be around to pick up the slack; since the lockout, this quintet is the NHL's top five in wins.

DAWN OF A NEW ERA

TIME FLOWS SWIFTLY, DOESN'T it? Ten years—a decade in just a snap of the fingers, the turn of a few pages, some clicks of the shutter. Careers begin, blossom, fade, end. Teams rise and fall, dynasties are born and die, the game revolutionizes itself and yet returns to its roots.

From the fear of a devastating nuclear winter—the lockout season of 2004–05—and the angst-y anticipation of the game's slow death following that year away, we have instead been graced with its rebirth. Torture any other metaphors you choose, be they moths-cocoons-butterflies, or fallow ground-green spring, but we maintain the game is better today from top to bottom than at any other time since expansion at least. Despite epochal change over this 10-year period, the stats and the players say so.

There is no comparison between NHL hockey today and that played around the turn of the millennium. Today's NHL is a faster game played by more highly skilled, better-conditioned, stronger athletes than the NHL of a decade ago. Could the greatest teams of any era compete today? Undoubtedly so. Would all those great historical teams succeed today? Perhaps. Might they still win Stanley Cup championships? Debatable.

Beyond debate is this. We end the decade more technologically savvy than ever, everything we want literally in the palms of our hands. We Google, we blog, we tweet. We live life 140 characters at a time, looking at results 1–10 of 49,800,000 found in 0.11 seconds

(those would be the search results for NHL, by the way), and click through 500 television channels, but only watch those in HD, please, while updating our Facebook status.

By any light and in most any field, this has been an amazing decade. If we've learned anything over the course of the last 10 years, from Y2K through iPods, iPads, and iPhones, it surely must be how foolish predicting the future can be. Still, given today's players and the vibrancy of today's NHL game, there's every reason to believe hockey's best is yet to come.

MICHAEL A. BERGER has served as the NHL's associate director of public relations, general manager of publishing, and editor of the League's official game program, *Goal*. He is the creator of the bestselling *Hockey Scouting Report*, and his work has been syndicated nationally in *USA Today*, *The Hockey News*, *Sport* magazine, on FOXSports.com, and on the Westwood One Radio Network. A four-time Emmy Award–winning associate producer for FOX Sports, he currently lives in Los Angeles.

Pursuit of the Stanley Cup excites a community like no other sporting event. Here, fans in Tampa Bay at an outdoor viewing party outside their arena watch nervously as the Lightning close in on their 2004 championship.

ABOVE: From 1994–95 through 2007–08, Mats Sundin was the face of the Toronto Maple Leafs; only Joe Sakic and Jaromir Jagr scored more points across that span.

RIGHT: After enduring a tumultuous summer that included team bankruptcy, the Phoenix Coyotes proved to be 2009–10's biggest story. The resurgent Coyotes earned a place in the Stanley Cup playoffs for the first time since 2002.

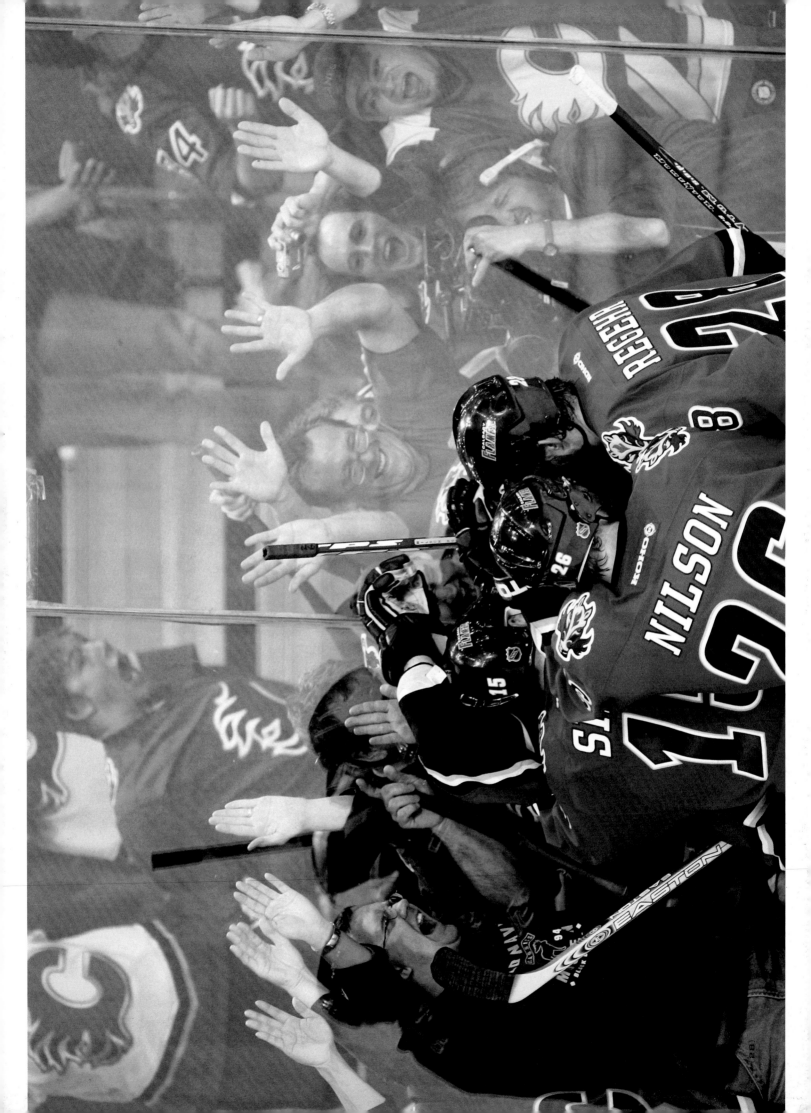

P. 28: Calgary fans pound the glass as the Flames celebrate a goal.

P. 29: A young Florida Panthers fan watches his team during warm-ups.

ABOVE: Alexander Frolov of the Kings keeps an eye on a budding hockey fan.

RIGHT: An image of the Stanley Cup is projected on the ice at Raleigh, North Carolina's RBC Arena prior to the start of Game 5 of the Eastern Conference Finals in 2006.

P. 32: Jarome Iginla watches Western Conference teammate Jonathan Toews tape his stick in the dressing room prior to the 2009 NHL All-Star Game in Montreal.

P. 33 LEFT: Darcy Tucker of the Maple Leafs prepares to leave the locker room along with teammates.

P. 33 RIGHT: Six-foot-nine Zdeno Chara ducks into the Bruins dressing room.

ABOVE: As Roberto Luongo knows, goaltending is the loneliest position in sports. Despite heartbreaking playoff losses to the Blackhawks in each of the last two seasons, Luongo holds the Canucks record for wins in a season (47 in 2006—07).

RIGHT: Patrick Kane's equipment for battle.

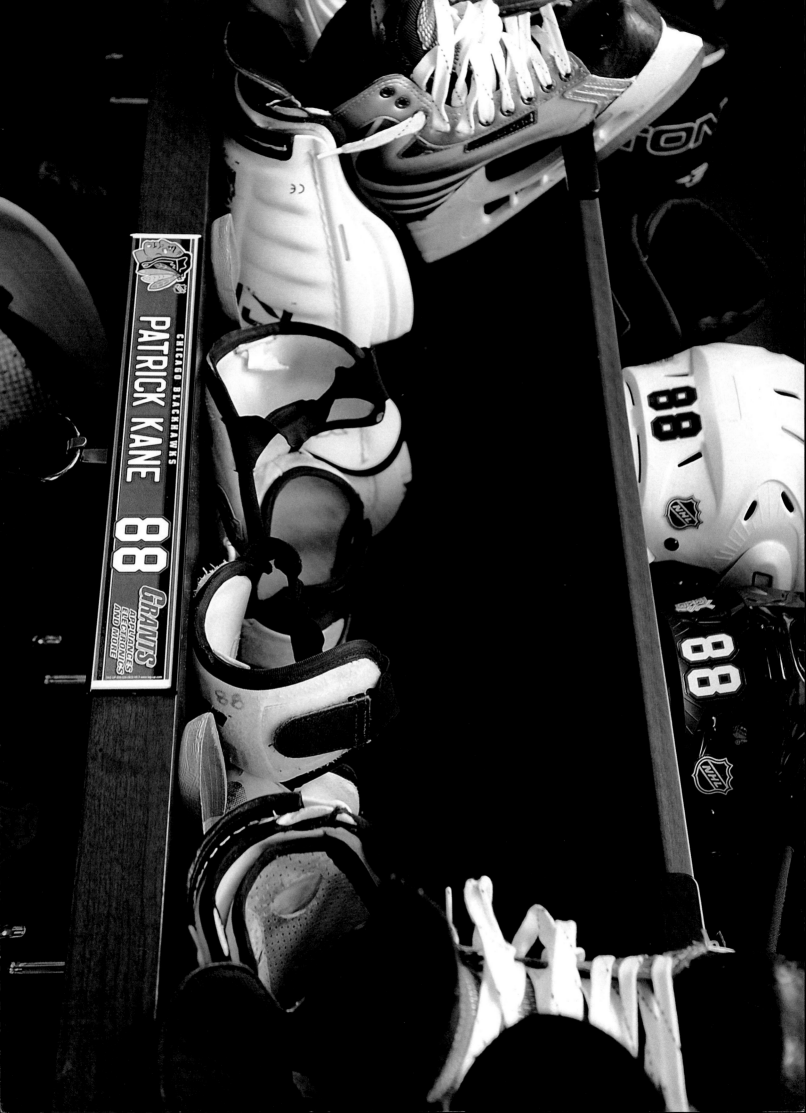

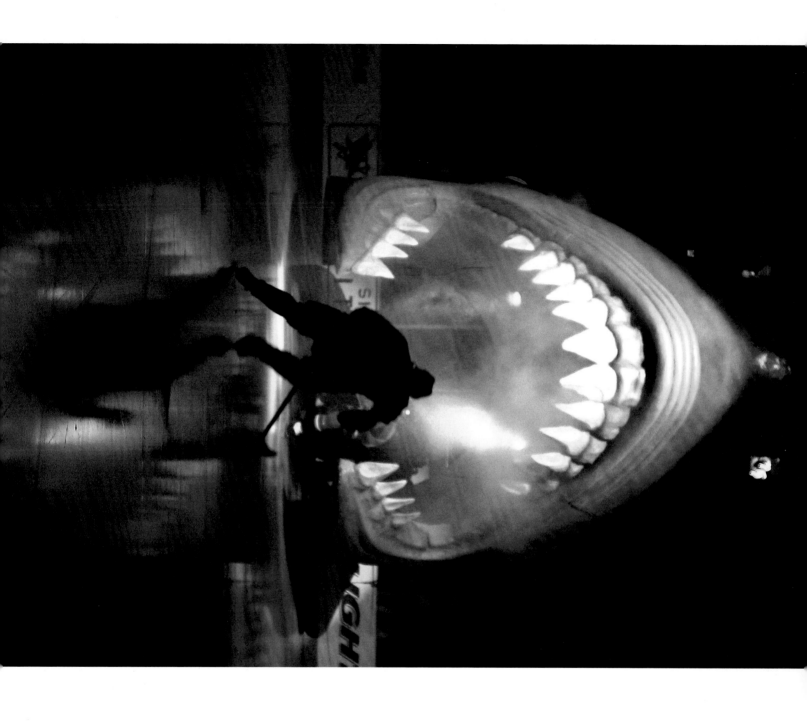

OPPOSITE PAGE: David Booth of the Panthers prepares to take the ice.

LEFT: Cue the *Jaws* theme—the Sharks emerge.

P. 38: Miikka Kiprusoff of the Calgary Flames (*left*) and Jonathan Quick of the Los Angeles Kings (*right*).

P. 39: Chris Chelios has played more games—both regular season and playoffs—than any other defenseman in NHL history.

RIGHT: Florida's Nathan Horton has his game face on.

OPPOSITE PAGE: As goes Miikka Kiprusoff, so go the Calgary Flames; Kiprusoff leads the NHL with 201 wins over the last five seasons.

P. 42: Ryan Kesler of the Canucks and Anze Kopitar of the Kings at faceoff.

P. 43 LEFT: Buffalo Sabre Maxim Afinogenov crosses centre ice.

P. 43 RIGHT: A puck stays lodged in a broken sheet of glass at Denver's Pepsi Center.

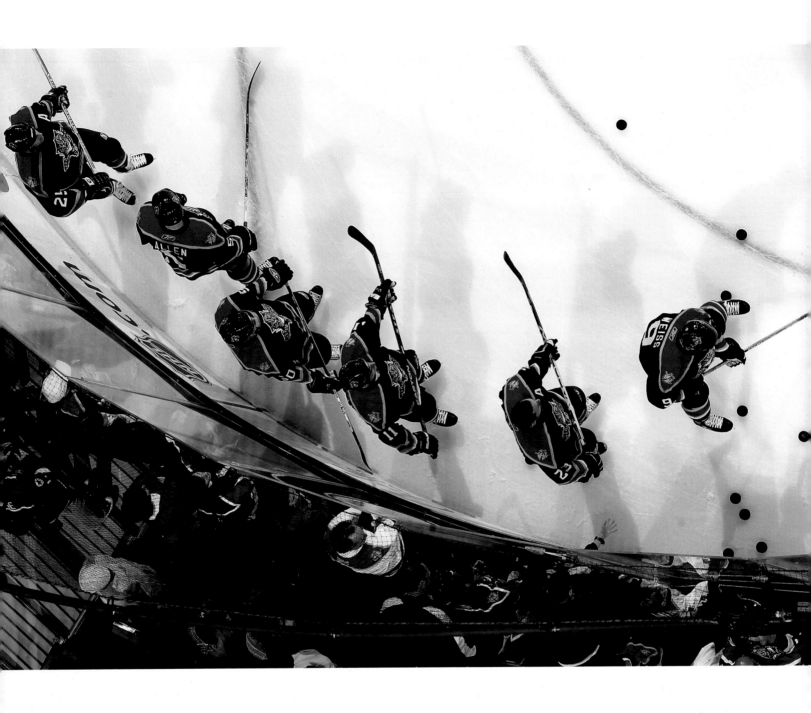

RIGHT: The Florida Panthers warm up on home ice.

OPPOSITE PAGE: Daymond Langkow, Mike Cammalleri, Jarome Iginla, and the rest of the Flames celebrate a game-winning shootout save by Miikka Kiprusoff.

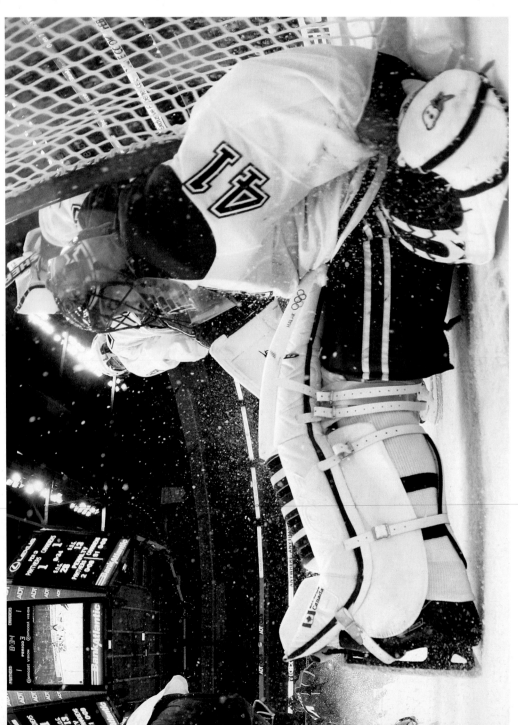

ABOVE: Jaroslav Halak led the surprising Montreal Canadiens to the Eastern Conference Final in the spring of 2010.

RIGHT: Across a 16-season NHL career, Dominik Hasek won two Cups, was twice named the NHL's MVP, and six times the League's best goaltender.

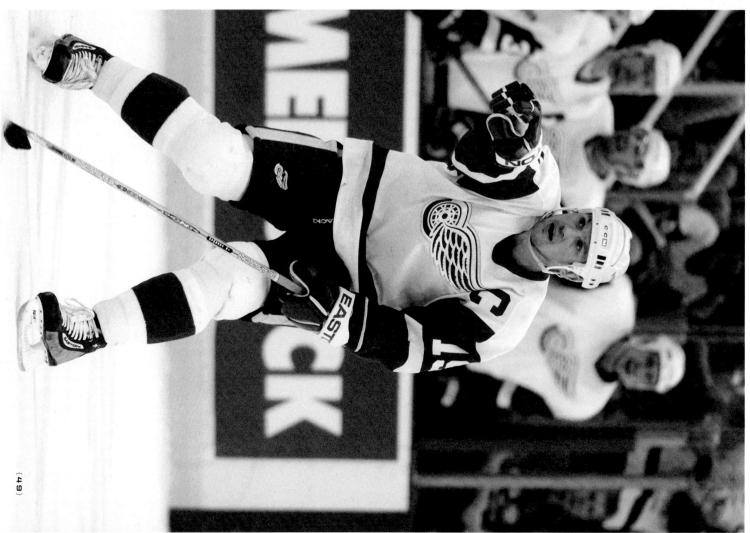

P. 48: Brian Leetch finished his career eighth all-time in scoring by defensemen.

P. 49 LEFT: Jaromir Jagr ranks ninth in career scoring in NHL history, five times led the NHL in points, and won the Hart Memorial Trophy as the League's MVP in 1999.

P. 49 RIGHT: Steve Yzerman is one of just three men to score as many as 155 points in a single season.

RIGHT: The rambunctious Brendan Shanahan twice won the Stanley Cup with Detroit and is one of just three players in NHL history to record 1,000-plus points and 2,500 penalty minutes.

OPPOSITE PAGE: Mark Messier's competitive fire is honoured by the League award for leadership bearing his name. As captain, he led two different teams to the Stanley Cup.

P. 52: Ed Belfour retired in 2007 with 484 wins, third all-time in NHL history. He won a Stanley Cup with the Stars in 1999.

P. 53: Luc Robitaille is perhaps the most popular Los Angeles King ever. Now an executive with the club, he won a Stanley Cup with the Red Wings in 2002.

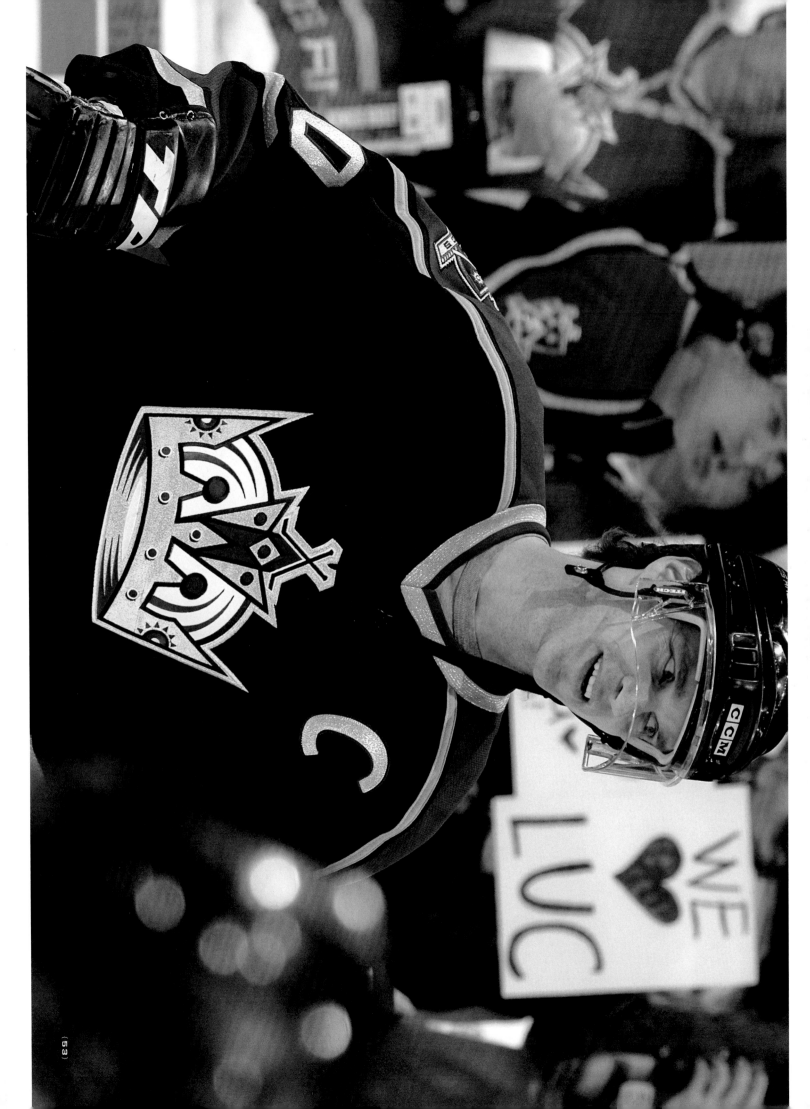

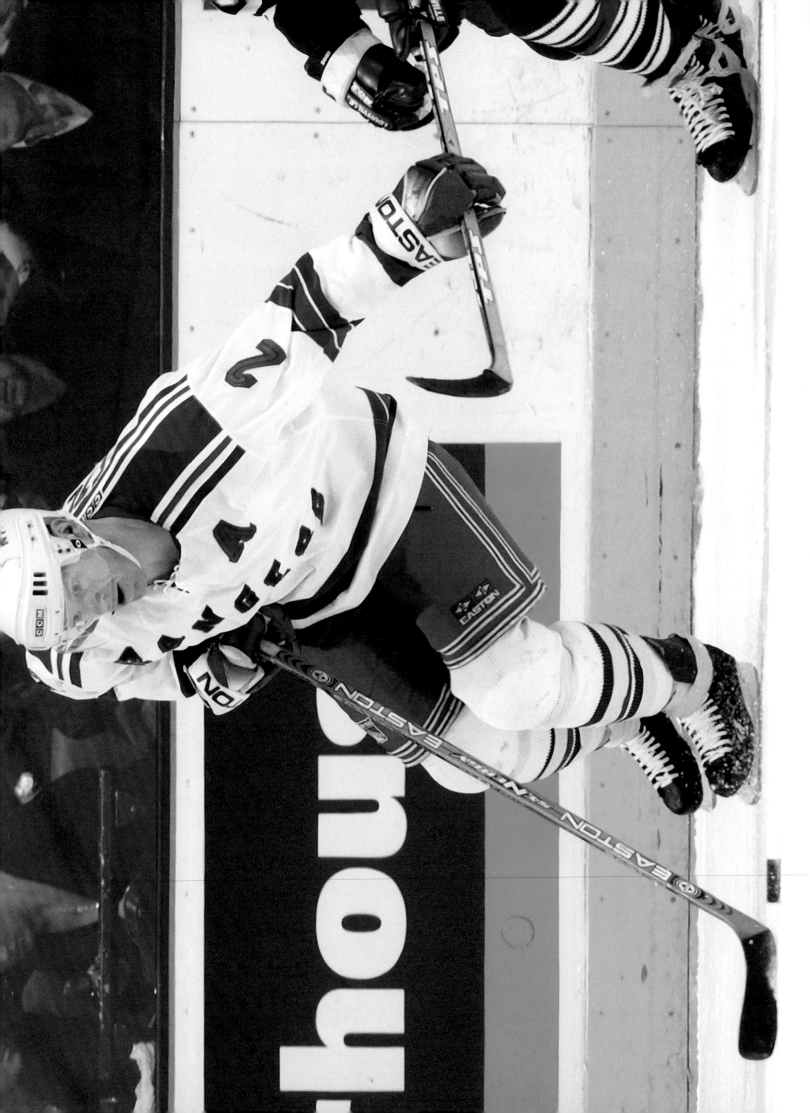

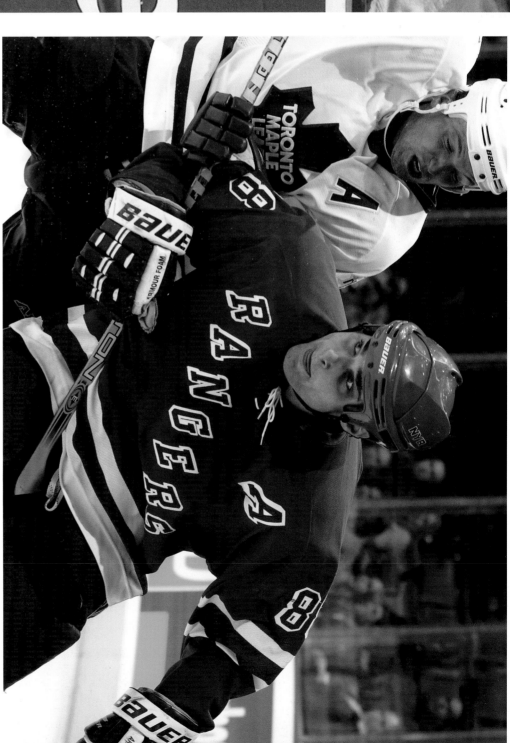

LEFT: New York Rangers Hall of Fame defenseman Brian Leetch is chased by former teammate Tie Domi. Leetch finished his NHL career as Domi's teammate once again in Toronto.

ABOVE: Eric Lindros made his biggest impact with the Philadelphia Flyers early in his career, scoring at a rate reserved for the game's greatest players, but his physical style took its toll.

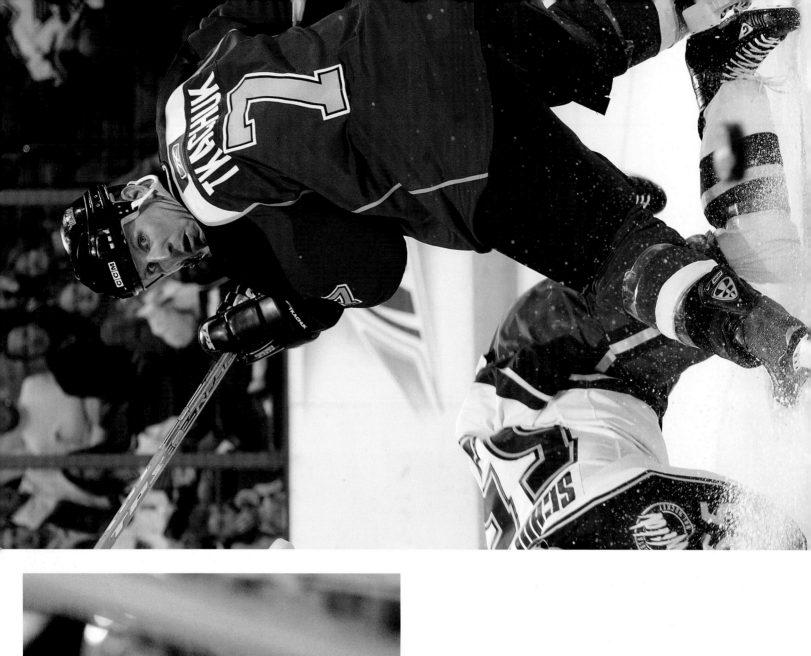

ABOVE: Mats Sundin was selected first overall by the Quebec Nordiques in the 1989 NHL Entry Draft. By the time he finished his NHL career in 2009, he had become the most prolific Swedish scorer in League history.

RIGHT: Like Sundin, Keith Tkachuk and Jeremy Roenick (*opposite page*) are among their country's best-ever NHLers; Roenick is third and Tkachuk fourth all-time in points by US-born players.

P. 58: Brett Hull captured his second Cup in 2002 with the Detroit Red Wings. Ignited in 1996, the fierce playoff rivalry between the Red Wings and Colorado Avalanche continues in this century, even though players like Patrick Roy (congratulating Hull), Ray Bourque (p. 59, *left*), and Peter Forsberg (p. 59, *right*) have retired.

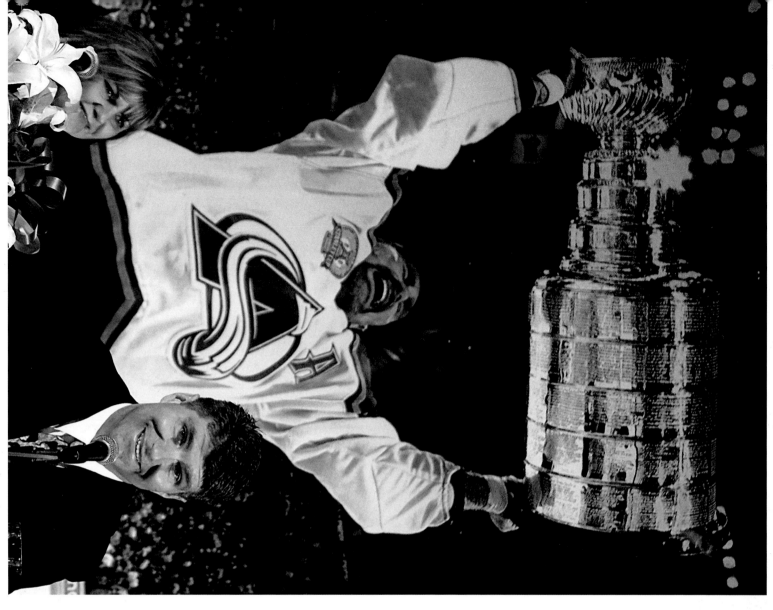

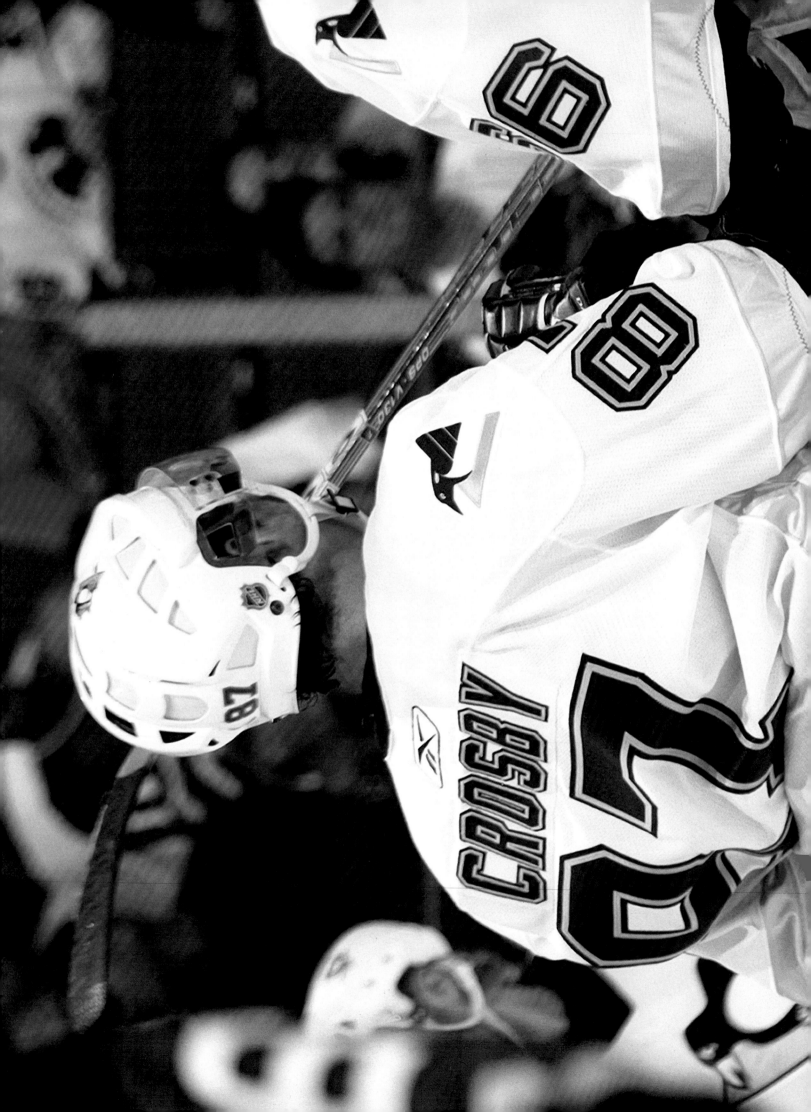

LEFT: After saving the Pittsburgh Penguins on the ice by leading them to two Stanley Cups, Mario Lemieux saved his best magic for off the ice—rescuing the club from bankruptcy and becoming the NHL's first player-owner. The Penguins today are among the League's most successful clubs, driven to superiority by the man Lemieux selected to walk in his footsteps, Sidney Crosby.

ABOVE: Once foes, brothers Scott and Rob Niedermayer celebrated a Stanley Cup championship together with the Anaheim Ducks in 2007.

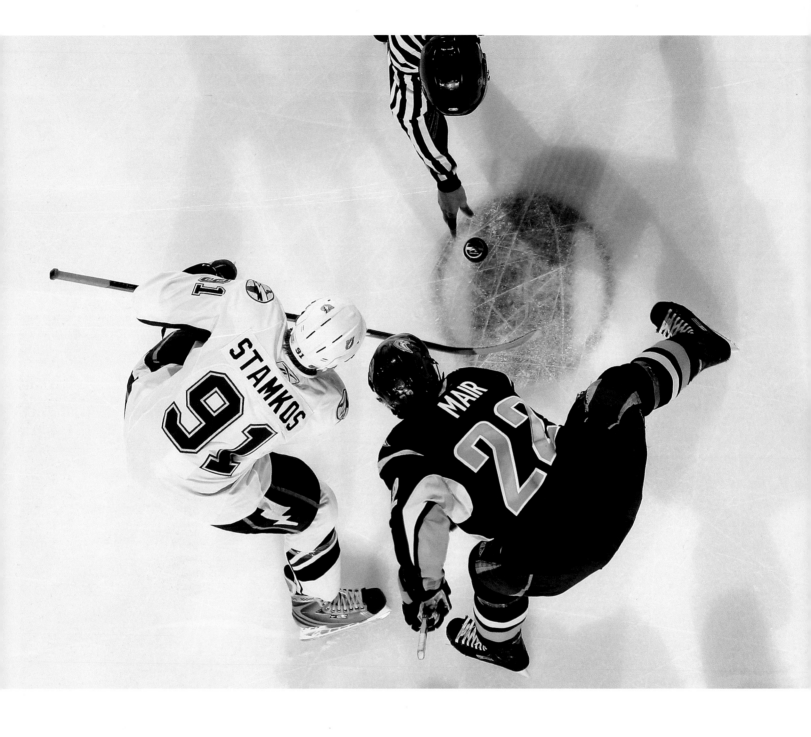

RIGHT: Like Sidney Crosby before them, first-round draft picks Steven Stamkos and David Perron (*opposite page*) are integral pieces in the reconstruction of Tampa Bay and St. Louis, respectively.

P. 64: Daniel Alfredsson of the Senators plays the puck under pressure from Alexander Khavanov of the Maple Leafs.

P. 65 LEFT: Matt Cooke of the Canucks is checked by Chris Pronger of the Edmonton Oilers.

P. 65 RIGHT: Make way for Shea—Nashville defenseman Shea Weber takes the ice.

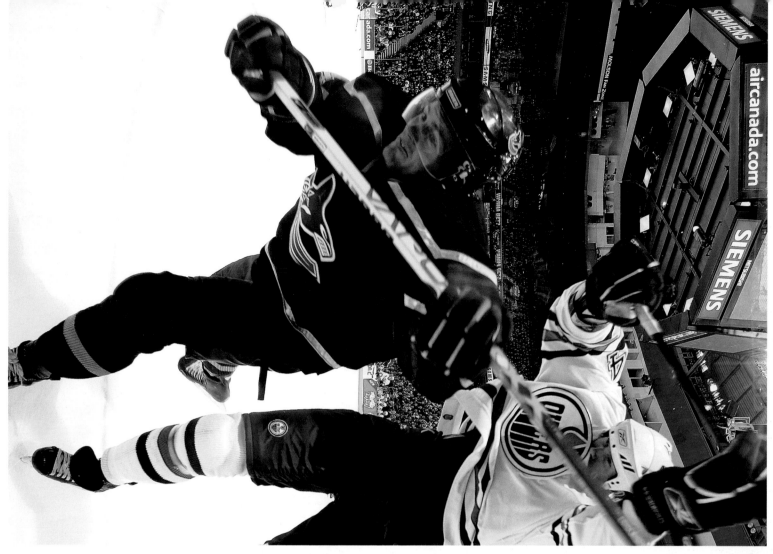

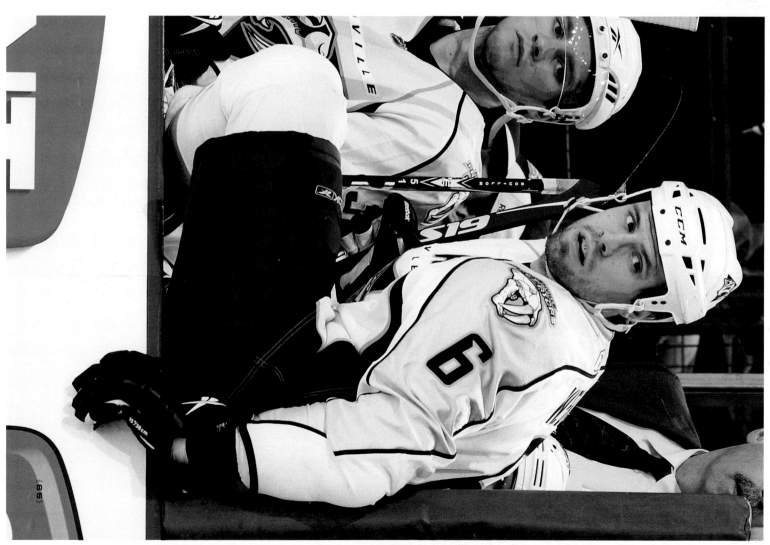

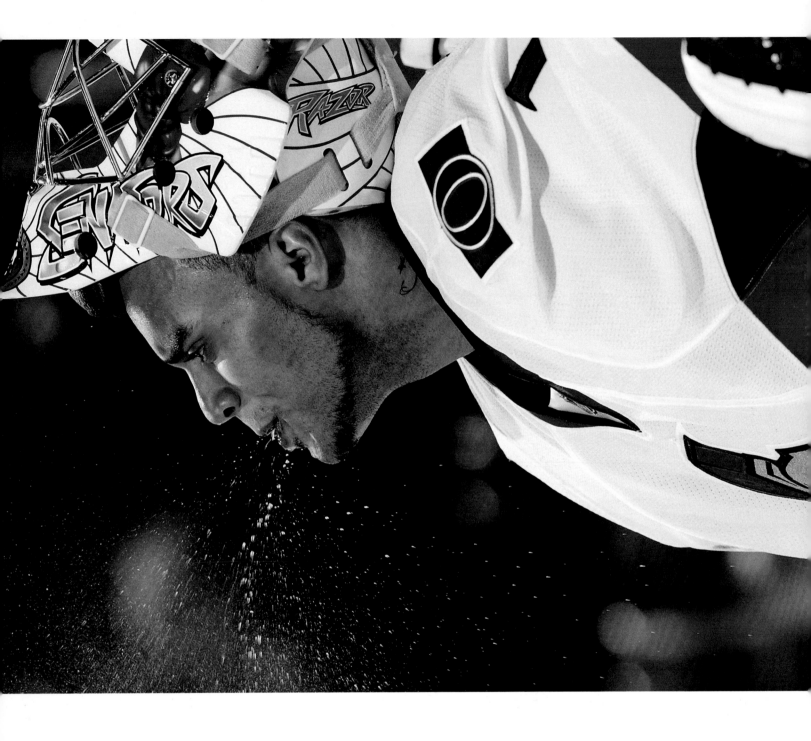

RIGHT: Fiery goalie Ray Emery as a member of the Senators.

OPPOSITE PAGE: Ottawa's Daniel Alfredsson is all wrapped up with no place to go, courtesy of New Jersey defenseman Scott Stevens—a position nearly all Stevens's opponents suffered throughout his 22-year Hall of Fame career.

P. 68: Buffalo's bright young goaltender Ryan Miller makes a glove save in front of Ottawa's Ryan Shannon.

P. 69: Detroit's Chris Osgood shuts down Nashville's Jason Arnott.

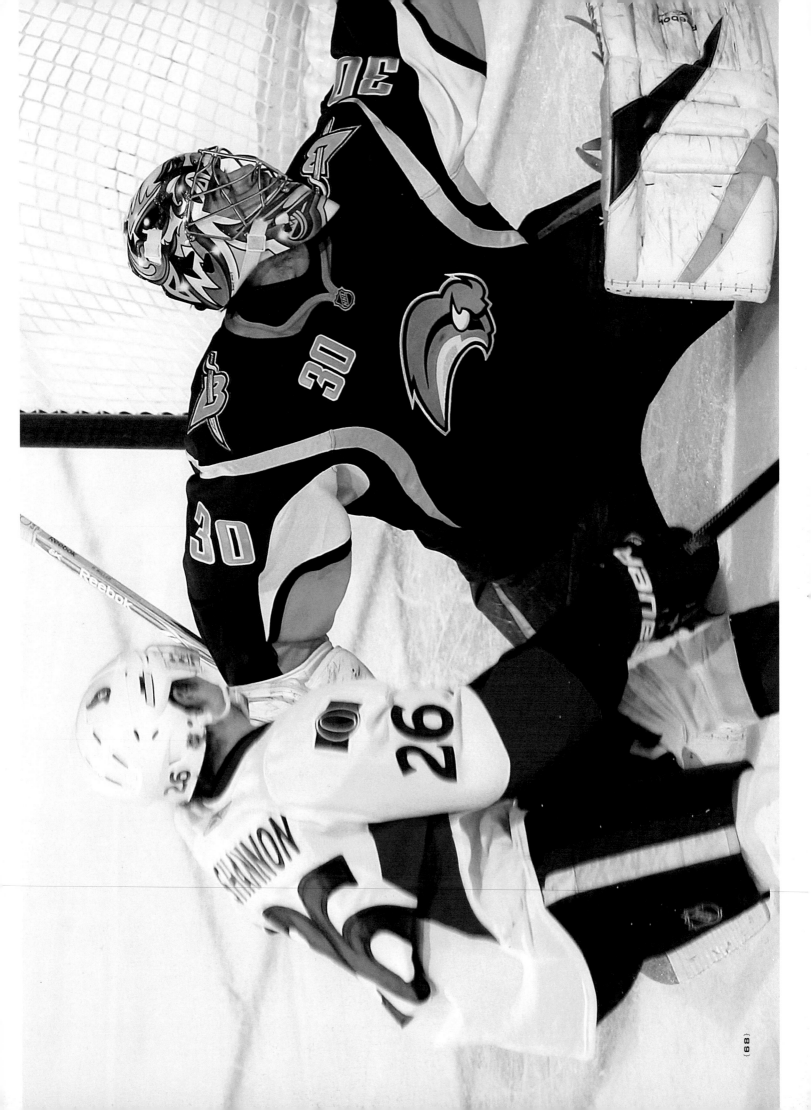

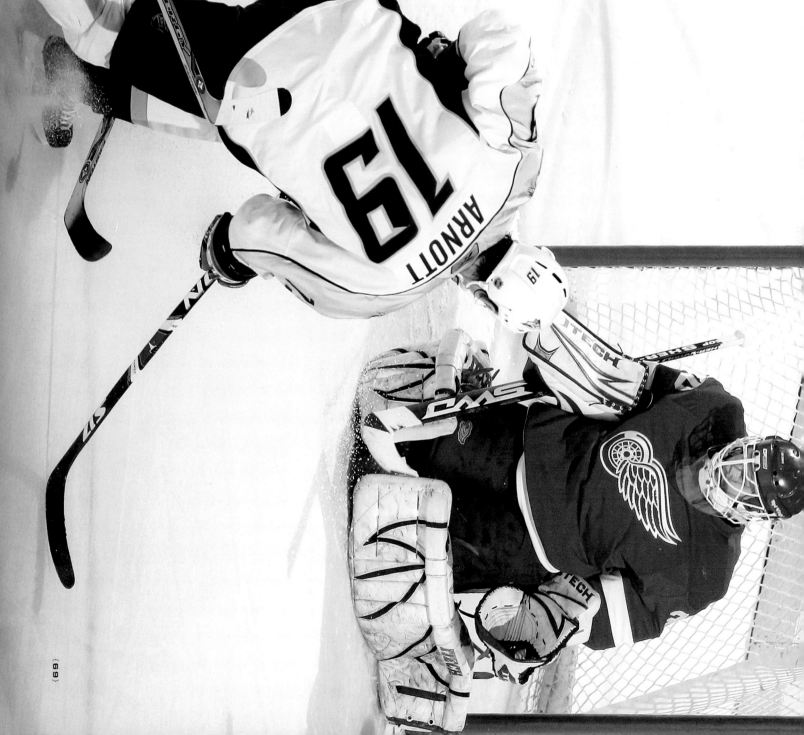

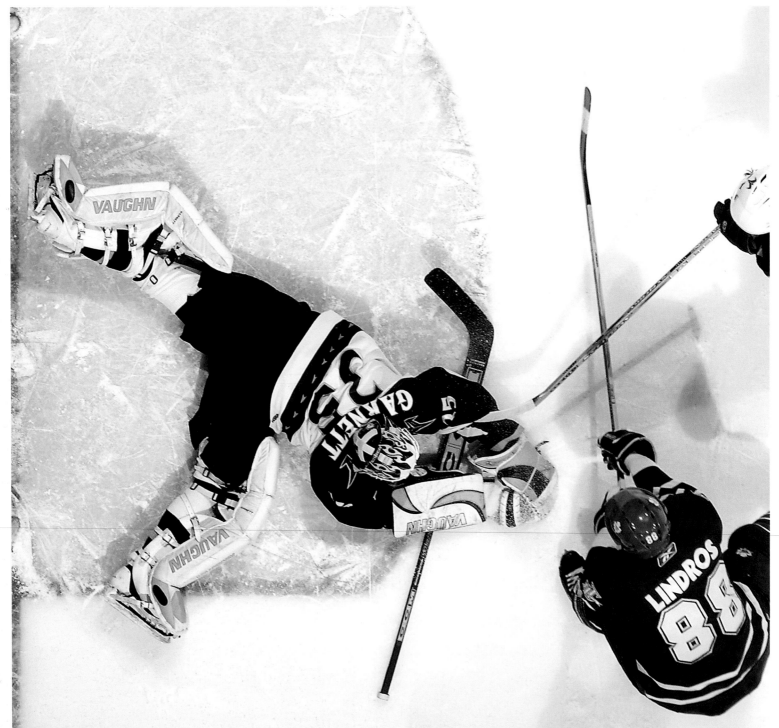

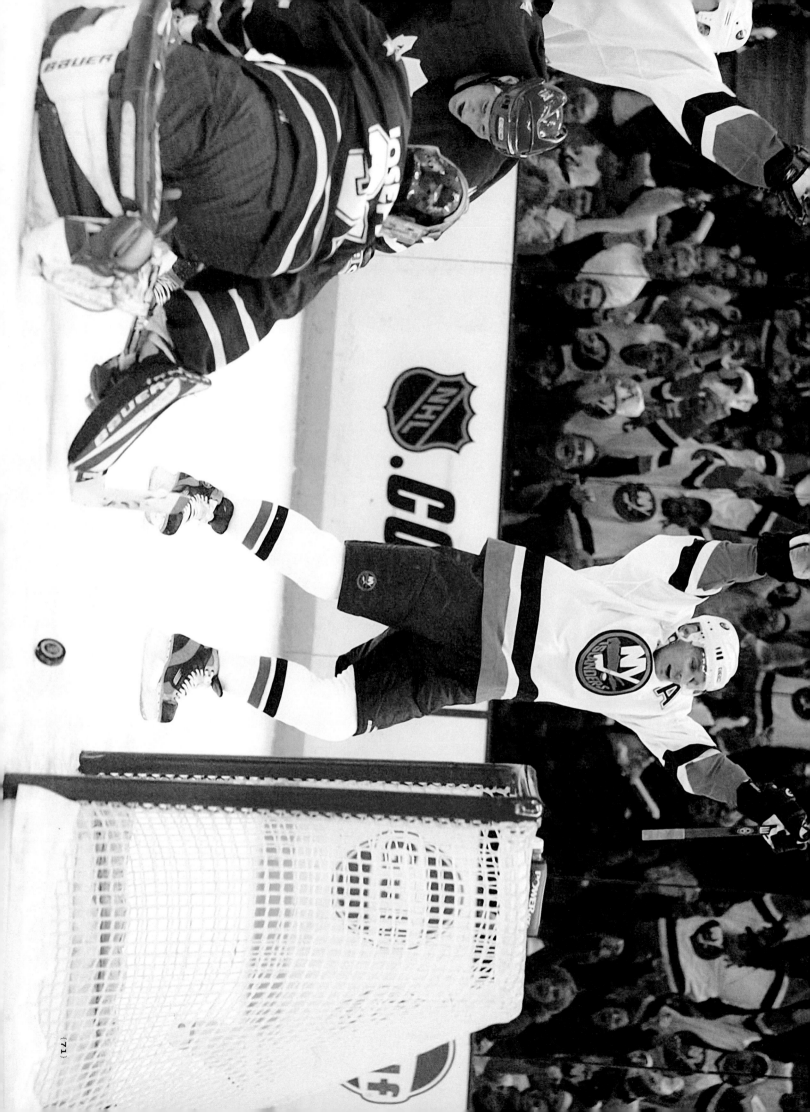

P. 70: Atlanta backstop Michael Garnett dives to cover the puck against Toronto's Eric Lindros.

P. 71: Mark Parrish of the Islanders celebrates his goal against Curtis Joseph of the Maple Leafs.

LEFT: Showdowns like this, once rare in the NHL, have become more common since the 2005 introduction of the shootout.

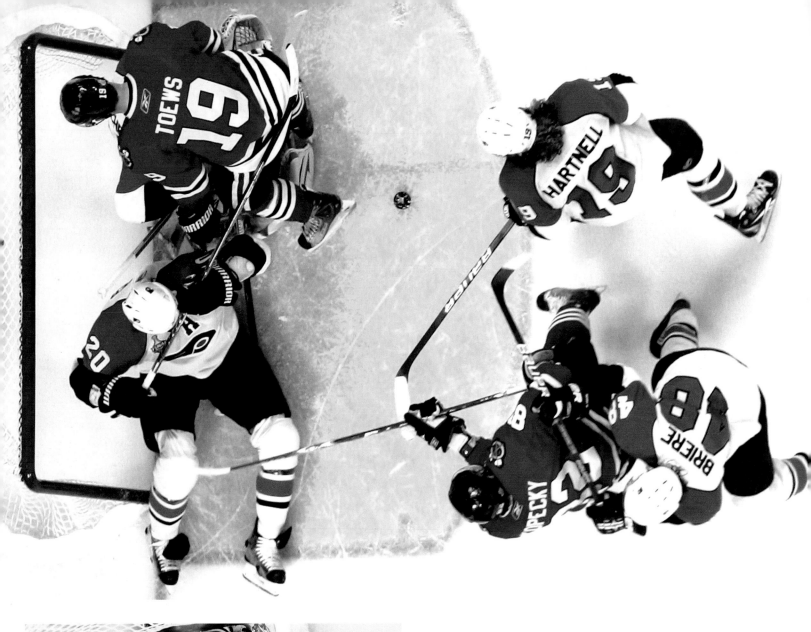

ABOVE: Philadelphia's Chris Pronger is swallowed by the goalmouth.

RIGHT: A scramble in the crease between the Flyers and Blackhawks.

OPPOSITE PAGE: Rick DiPietro of the Islanders makes a save against Jeff Carter of the Flyers.

LEFT: Anaheim's Ilya Bryzgalov sprawls on the ice against Colorado.

ABOVE: Martin Brodeur of the Devils makes a stop against the Penguins.

ABOVE: Jere Lehtinen of the Stars and Sheldon Brookbank of the Ducks battle for the puck.

RIGHT: The snow flies as Anaheim's Corey Perry collides along the boards with Vancouver's Andrew Alberts.

OPPOSITE PAGE: Oh, brother. Two halves of a couple of the NHL's best brother acts, Vancouver's Daniel Sedin and Anaheim's Scott Niedermayer, reintroduce themselves in a Pacific Division act of sibling rivalry.

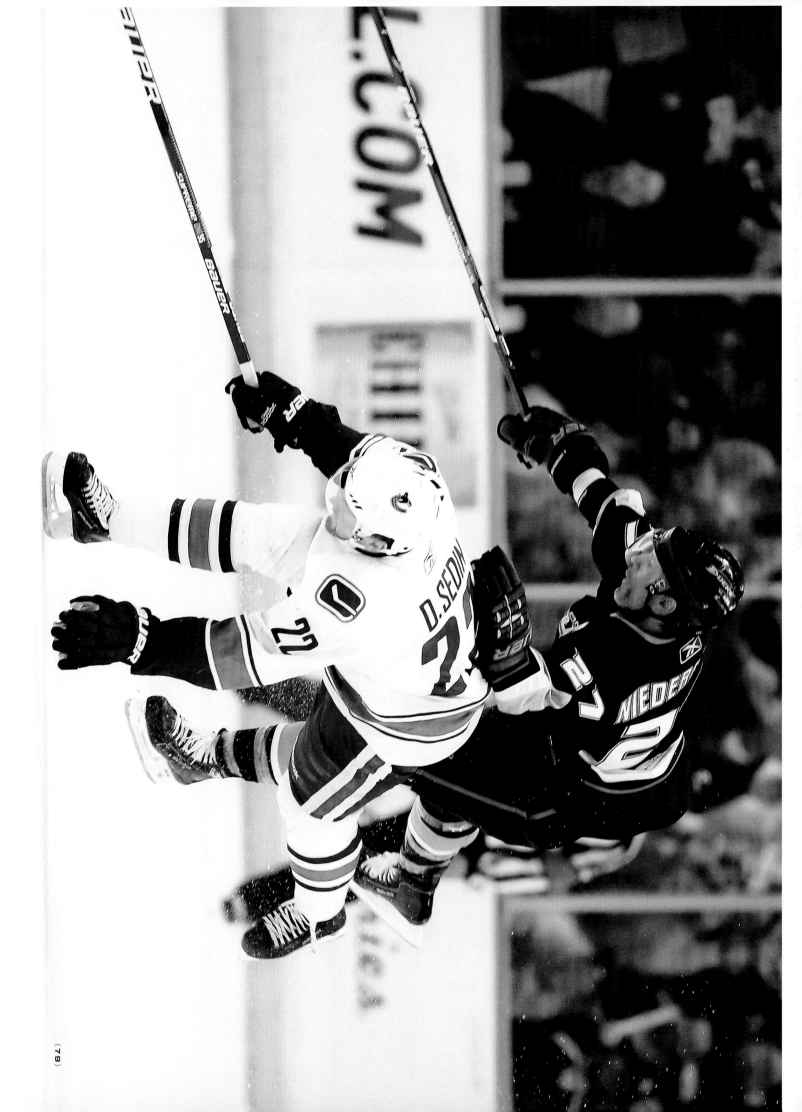

P. 80: Niklas Backstrom of the Wild stops the Oilers cold.

P. 81: Minnesota's Cal Clutterbuck is sent airborne after colliding with Philip Larsen of Dallas.

OPPOSITE PAGE: Cam Janssen of the Blues shoots the puck as Ian Laperriere of the Flyers defends.

LEFT: Chris Pronger's nearly unmatched combination of skill and strength has helped him carry his teams to the Stanley Cup Final in three of the last five seasons.

P. 84: Mike Modano, here celebrating with his Dallas teammates, is the greatest scorer the US has ever produced. He has scored more goals (557) and tallied more points (1,359) than any other US player ever.

P. 85: Joe Pavelski of the Sharks attempts a wraparound shot on Marty Turco of the Stars.

OPPOSITE PAGE: Jussi Markkanen of the Oilers makes a save against Mark Recchi of the Hurricanes.

LEFT: Edmonton's Markkanen making another dramatic stop.

P. 88: Pascal Dupuis of the Penguins evades the defense of Marty Reasoner and Zach Bogosian of the Thrashers.

P. 89: Pittsburgh's Sidney Crosby battles for the puck against Atlanta's Eric Boulton.

P. 90: Ondrej Pavelec of the Thrashers falls in front of the goal against the Blackhawks.

P. 91: Boston's Patrice Bergeron scrambles for the loose puck against Buffalo.

RIGHT: A downcast Evgeni Nabokov of San Jose steps off the ice after a loss.

OPPOSITE PAGE: The Sharks celebrate in front of Paul Mara of the Coyotes.

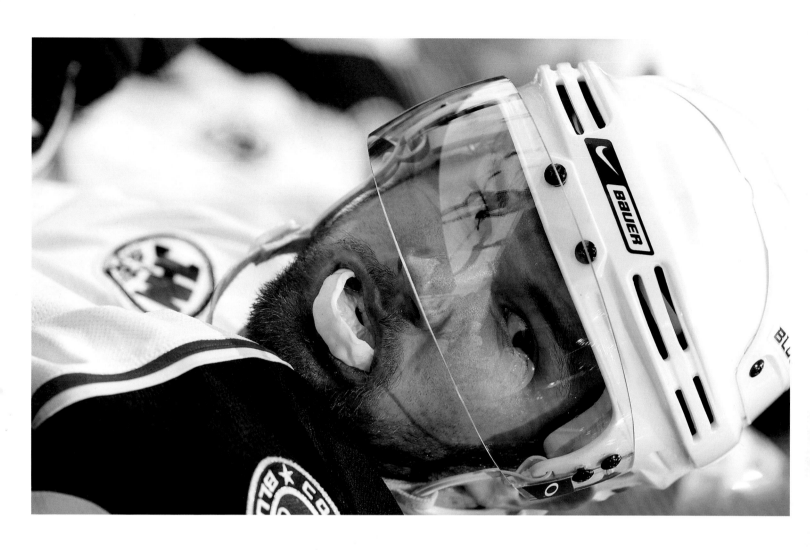

OPPOSITE PAGE: The Blue Jackets
congratulate each other after a win against the
Oilers in Edmonton.

LEFT: Superstar left wing Rick Nash of the Blue
Jackets has gained awards for his scoring ability,
and gained respect for his all-around game.

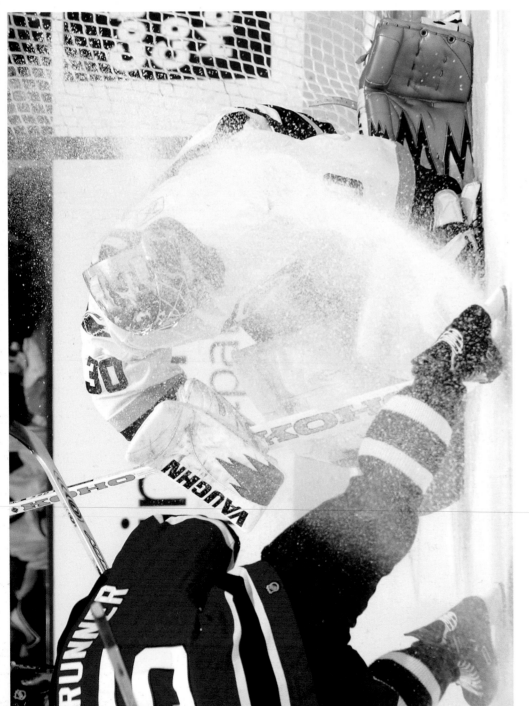

ABOVE: Goalie Cam Ward of Carolina covers the puck and gets a snow shower from Jamie Langenbrunner of New Jersey.

RIGHT: New Jersey's Martin Brodeur holds nearly every goaltending record imaginable. It is impossible to consider any player more vital to his team's success than Brodeur has been for New Jersey.

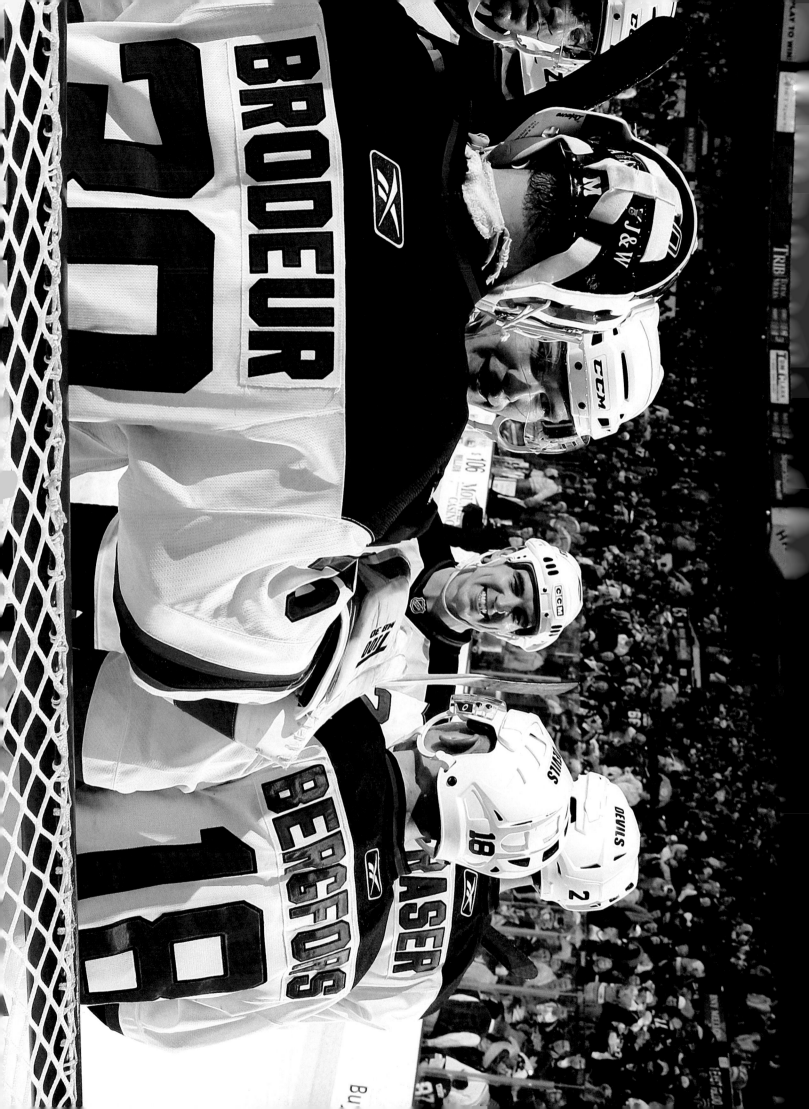

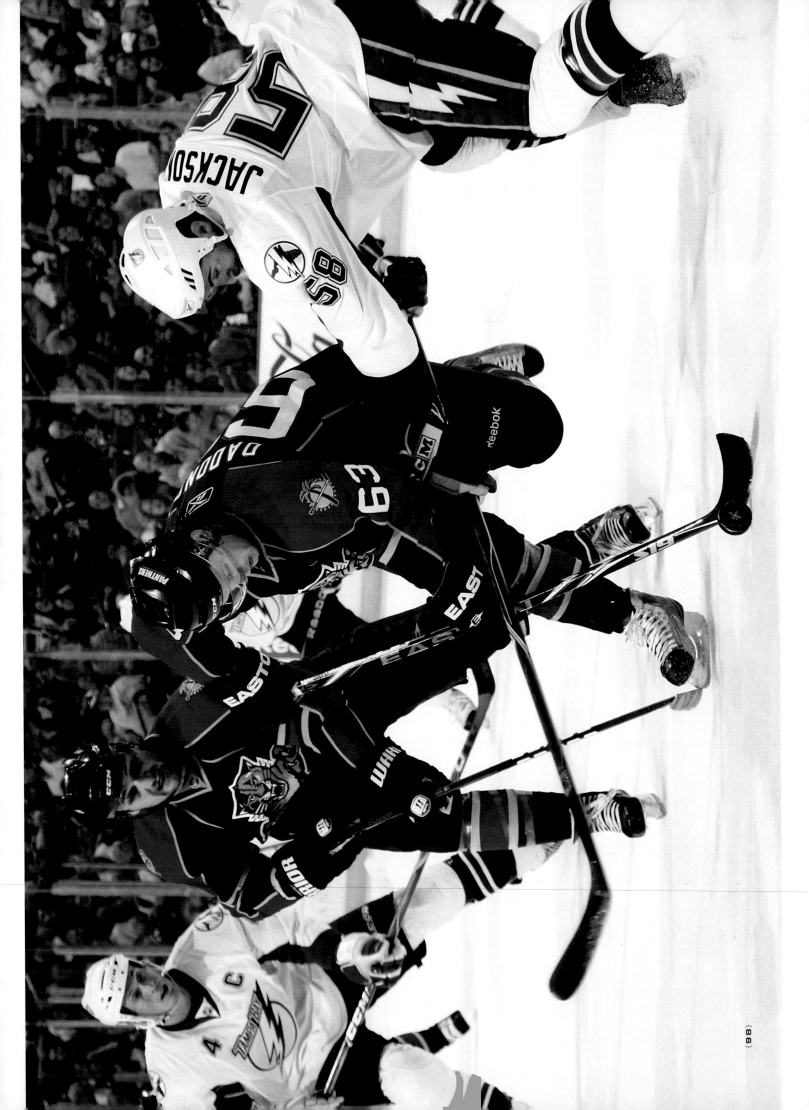

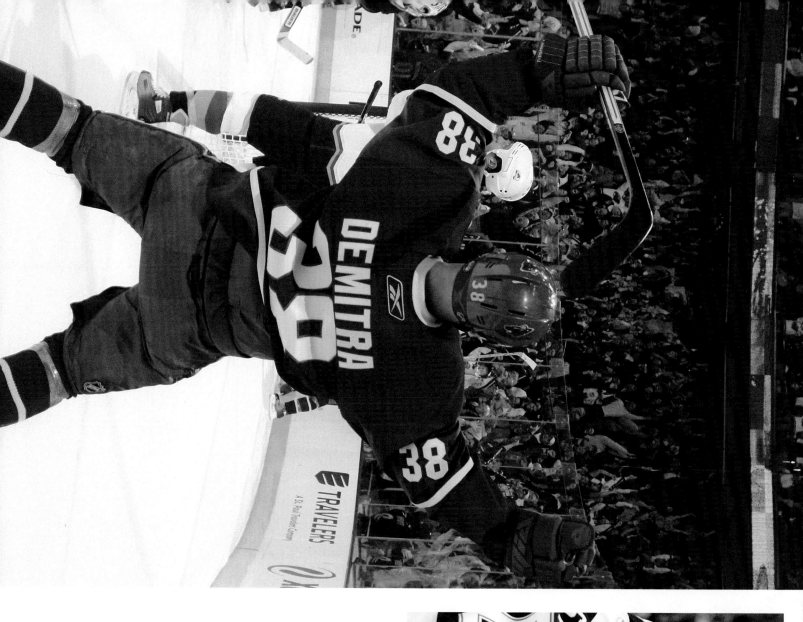

OPPOSITE PAGE: Evgeny Dadonov of the Panthers crosses sticks with Scott Jackson of the Lightning.

LEFT: Pavol Demitra of the Wild celebrates overtime victory against the Avalanche.

ABOVE: Tampa Bay's Ruslan Fedotenko celebrates with Cory Stillman after scoring a goal against the Calgary Flames during the 2004 Stanley Cup Final.

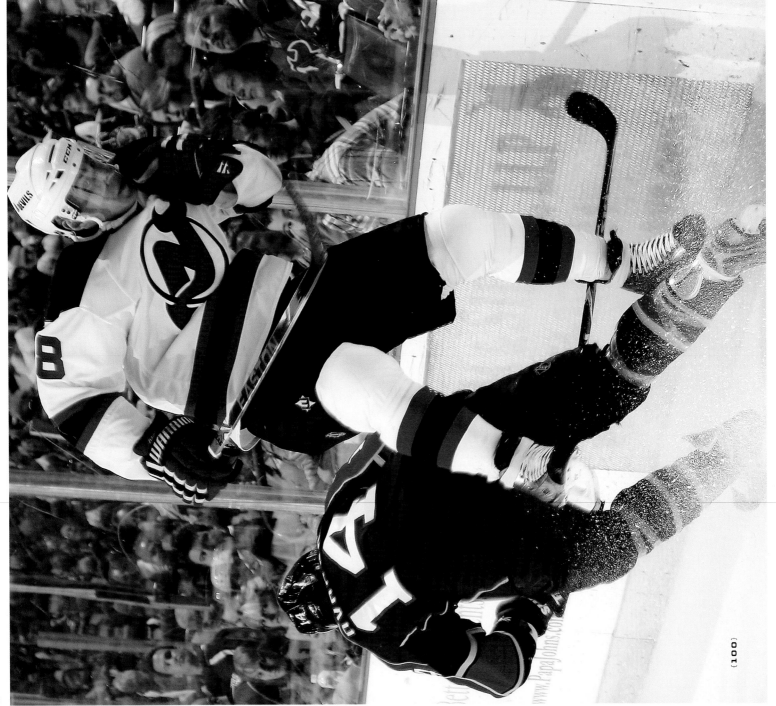

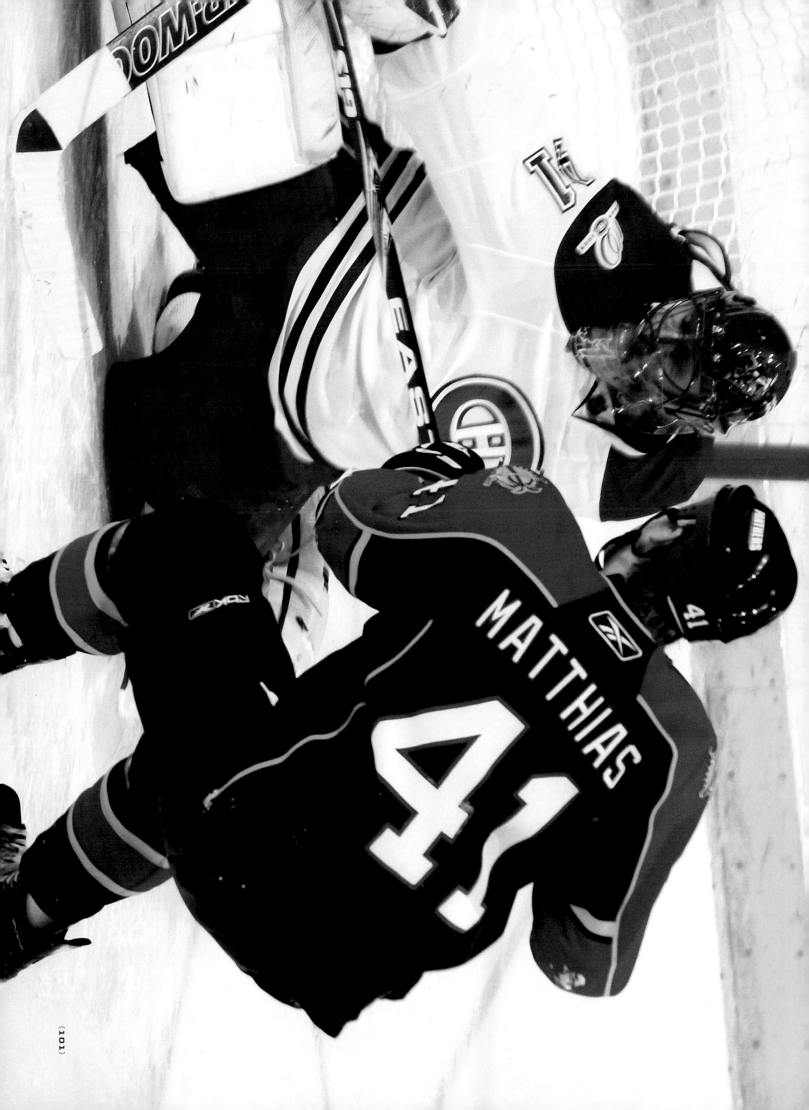

P. 100: Dainius Zubrus of the Devils jumps to avoid a collision with Radek Dvorak of the Florida Panthers.

P. 101: Florida's Shawn Matthias scores a penalty shot on Montreal's Jaroslav Halak.

OPPOSITE PAGE: Mike Komisarek of the Canadiens knocks the helmet off Alexander Frolov of the Kings as they battle along the boards.

LEFT: Montreal's Alex Kovalev tries an upside-down goal celebration in front of teammate Saku Koivu while New York goalie Henrik Lundqvist kneels dejected.

ABOVE: Sami Lepisto and Keith Yandle of Phoenix embrace after a goal.

RIGHT: Ilya Bryzgalov of the Coyotes scoops the puck out of the net after a Detroit goal.

OPPOSITE PAGE: After retiring in 1999, Wayne Gretzky became part of the Phoenix Coyotes ownership group in 2001 and stepped behind the bench in 2005. Befitting his legacy as the game's greatest player and Canada's greatest athlete, Gretzky served as the final torchbearer during the opening ceremonies for the 2010 Winter Olympics.

OPPOSITE PAGE: Vancouver's Swedish sensations: Mikael Samuelsson (centre), flanked by the Sedins—Henrik (*left*) and Daniel.

LEFT: Shane O'Brien of the Canucks sports some fresh stitches for Game 6 of the 2010 Western Conference Semifinals.

P. 108: Vancouver superstar Roberto Luongo gloves the loose puck as Derek Boogaard of the Minnesota Wild skates in for a rebound.

P. 109: Key figures in the Vancouver Canucks franchise during this decade: Trevor Linden and Mattias Ohlund.

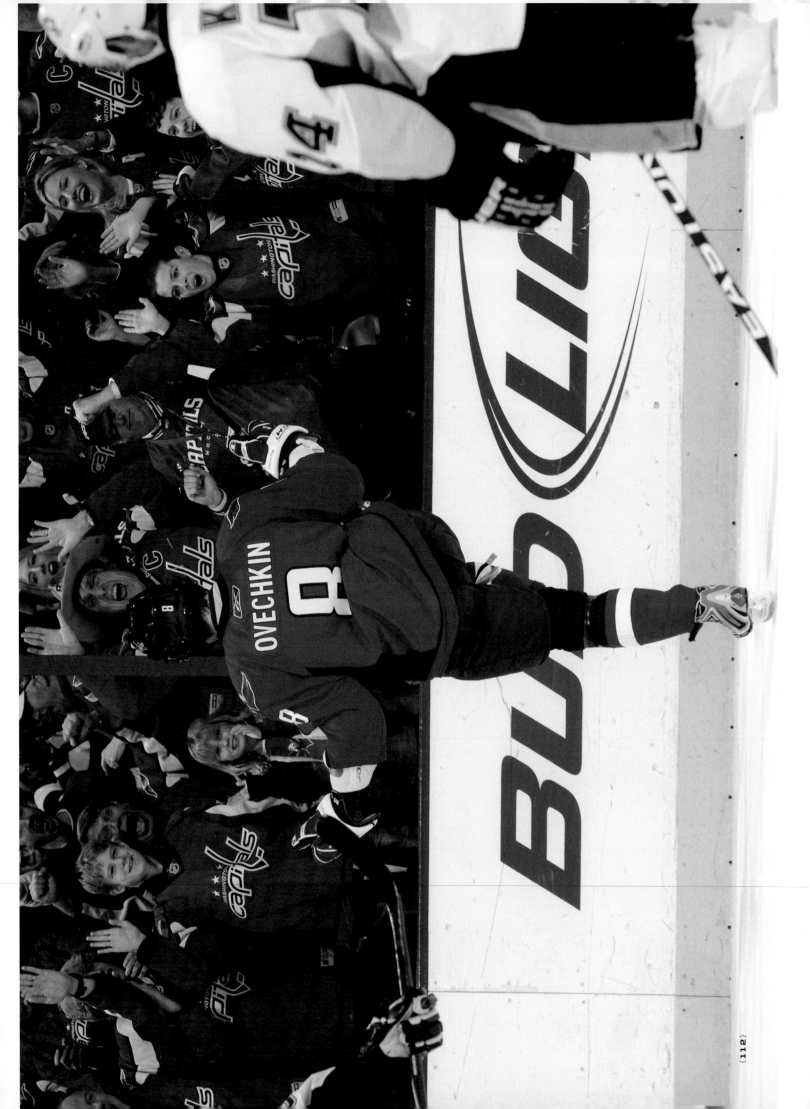

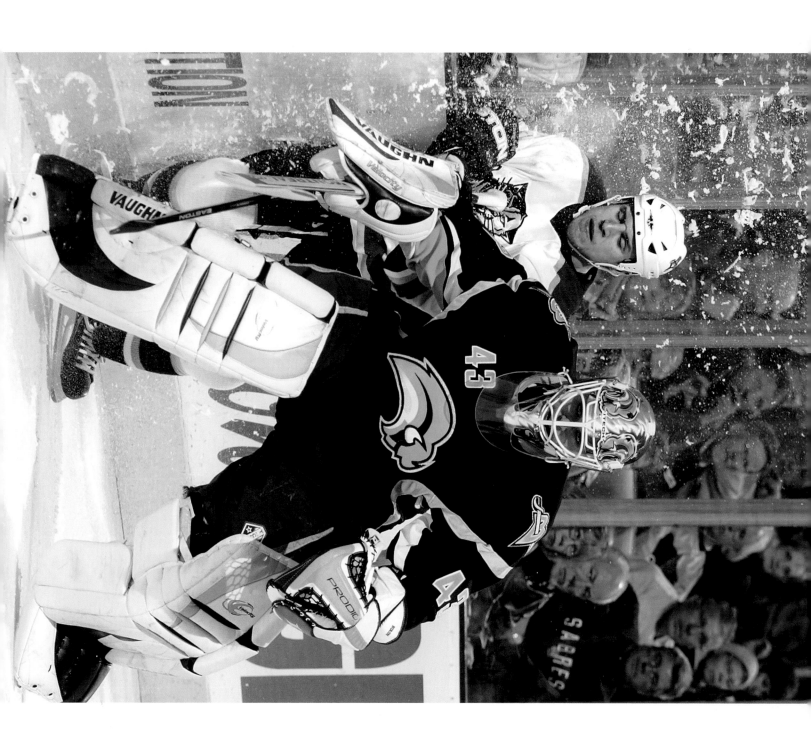

P. 110 LEFT: Six-time All-Star Paul Kariya winds up for a shot with the St. Louis Blues.

P. 110 RIGHT: Scott Hartnell of the Philadelphia Flyers collides with Zdeno Chara of the Boston Bruins.

P. 111: Ruslan Salei of the Panthers gets crossed up with Todd Marchant of the Ducks.

OPPOSITE PAGE: Washington's Alexander Ovechkin displays nightly a joy and emotional commitment that inspires his team, frustrates his opposition, and delights his fans.

LEFT: Martin Biron of the Sabres tangles with Panther Gregory Campbell.

ABOVE: Chicago captain Jonathan Toews fights for position with Calgary's Rene Bourque.

RIGHT: Vincent LeCavalier is the very definition of a franchise player. Entering the 2010–11 season, the 30-year-old centre holds the Tampa Bay Lightning's career records for games played, goals, assists, and points.

OPPOSITE PAGE: Alexander Ovechkin firing away. Since he entered the League five years ago, no player has scored more goals.

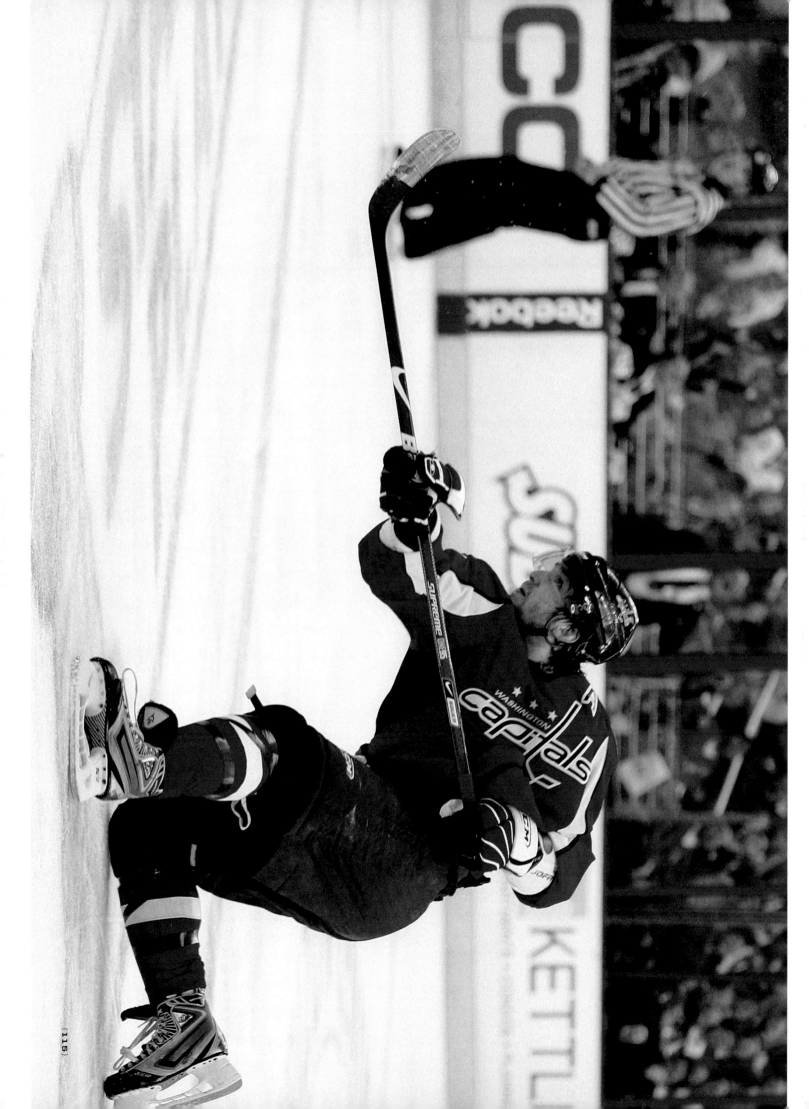

PP. 116–19: Calgary's Miikka Kiprusoff (p. 116), New York's Henrik Lundqvist (p. 117), and Pittsburgh's Marc-André Fleury (p. 118) are all ranked in the top 10 in total wins over the last five seasons. For his career (entering the 2010–11 season), Detroit goaltender Chris Osgood (left) ranks 10th all-time in regular-season wins.

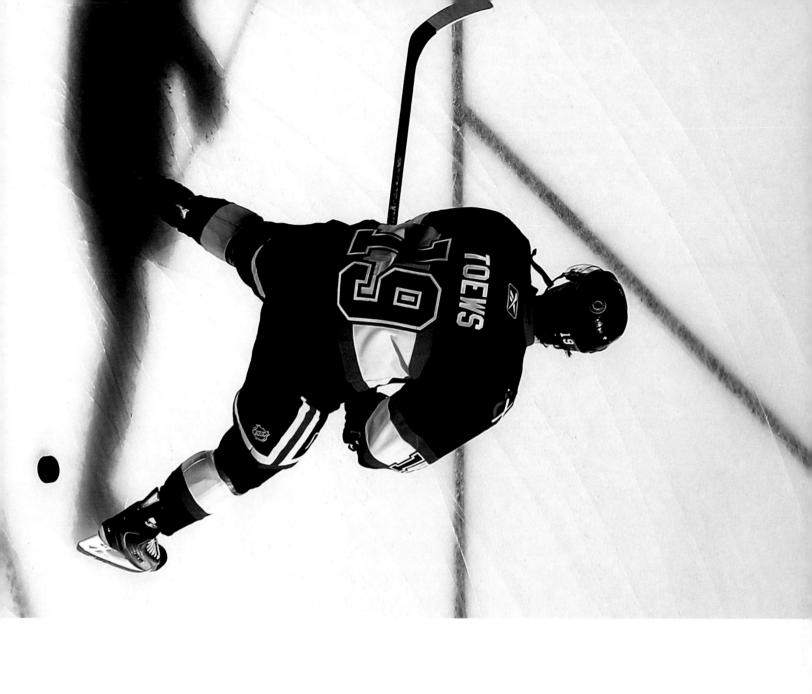

PP. 120–1: Buffalo Sabres youngster Tyler Ennis (p. 120) has much he can learn from Jarome Iginla (p. 121) of the Calgary Flames. Ennis scored three goals in his first season of NHL play during 2009–10; Iginla has scored 30-plus goals in each of his last nine seasons, and has scored more total goals than any NHLer during this decade.

LEFT: Chicago's Jonathan Toews already knows a thing or two, despite his relative young age. At just 22 years old, Toews has already captained his team to a Stanley Cup championship.

P. 124: Buffalo's Ryan Miller reaches out with his stick to make a save against New York's Marian Gaborik.

P. 125: Chicago spark plug Patrick Kane scored last season's thrilling Stanley Cup–winning goal.

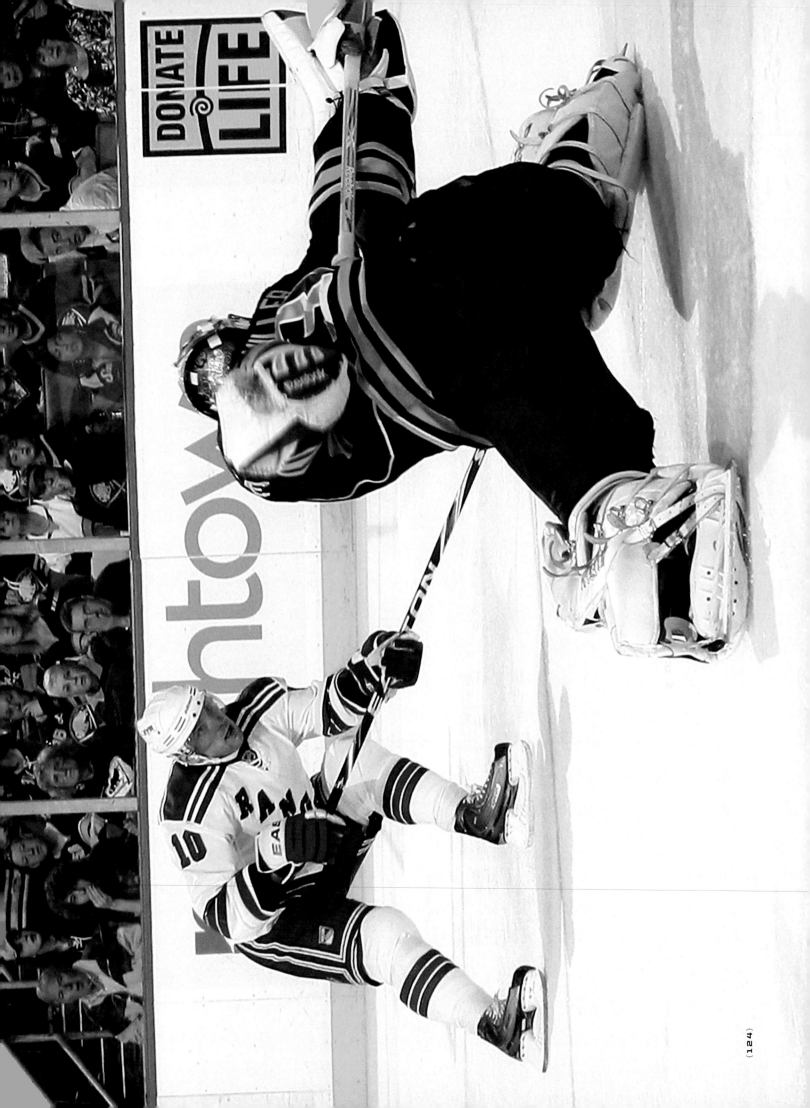

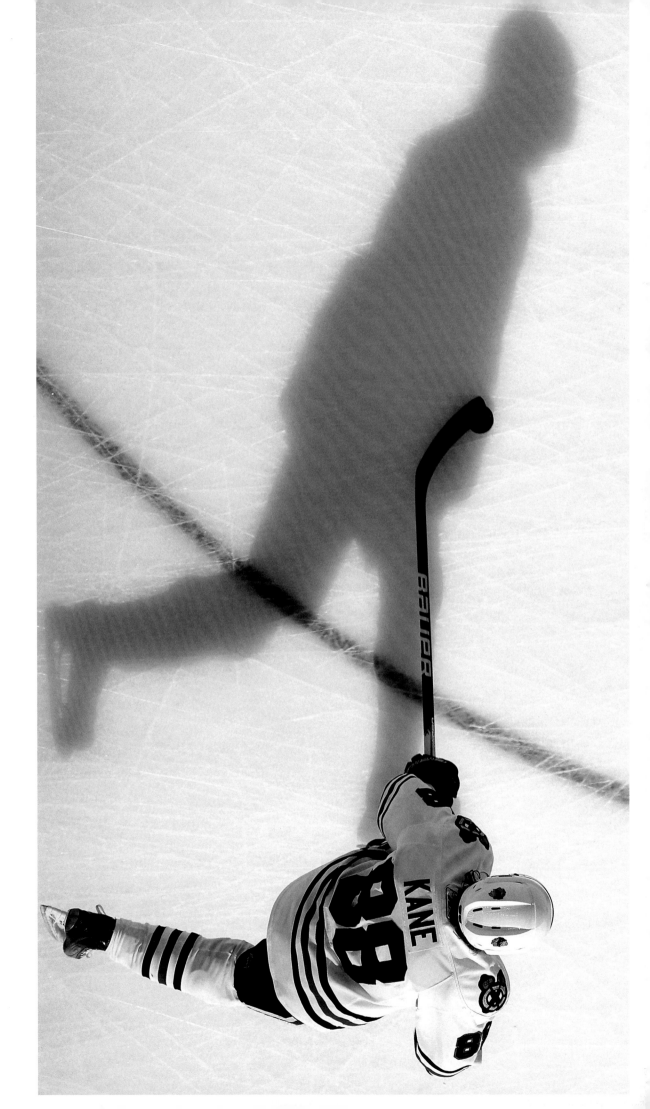

RIGHT: In 2004, Brad Richards won the Conn Smythe Trophy as playoff MVP with the Cup-winning Tampa Bay Lightning.

OPPOSITE PAGE: Ilya Kovalchuk leads his old team the Thrashers all-time in scoring, with 328 goals.

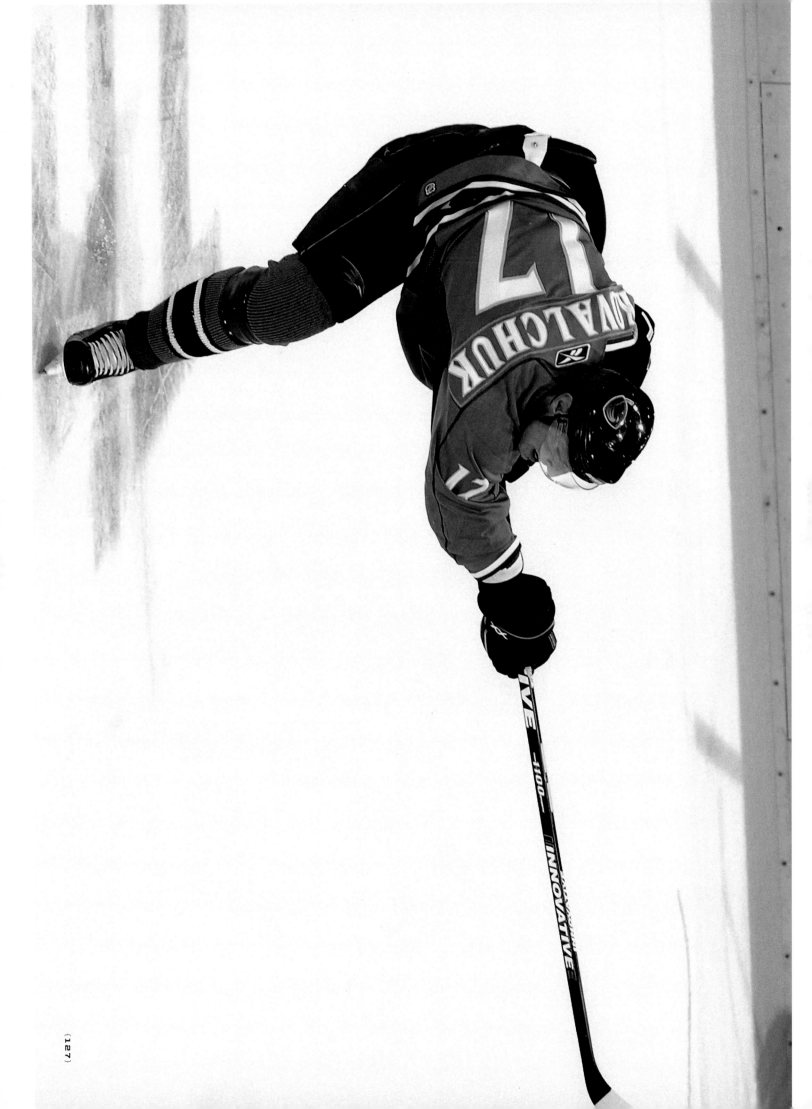

LEFT: Members of the St. Louis Blues stand for the singing of the anthem at the Pepsi Center in Denver.

PP. 130-2: The oldest of the NHL's franchises, the Montreal Canadiens, celebrated their centennial in 2008 and 2009. The sweaters worn on these pages date from the 1915 season. Carey Price (p. 131) even donned a pair of vintage pads.

P. 133: J.S. Giguere, Francois Beauchemin, Chris Kunitz, and Rob Niedermayer of the 2007 champion Anaheim Ducks show off Lord Stanley's Cup near London's Tower Bridge.

P. 134: The NHL abroad. Action during the 2007 season-opening game between Anaheim and Los Angeles at London's O2 Arena.

P. 135: A dizzying view between periods during the 56th NHL All-Star Game at Philips Arena in Atlanta.

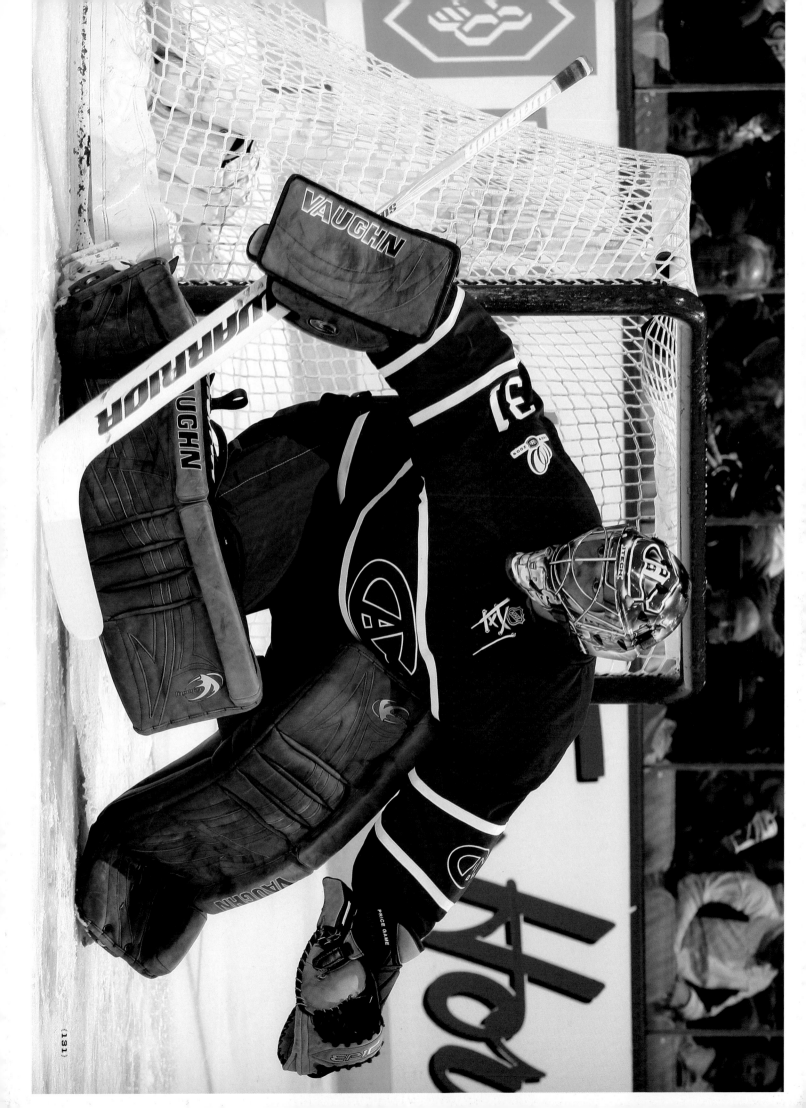

bonjourquebec.com

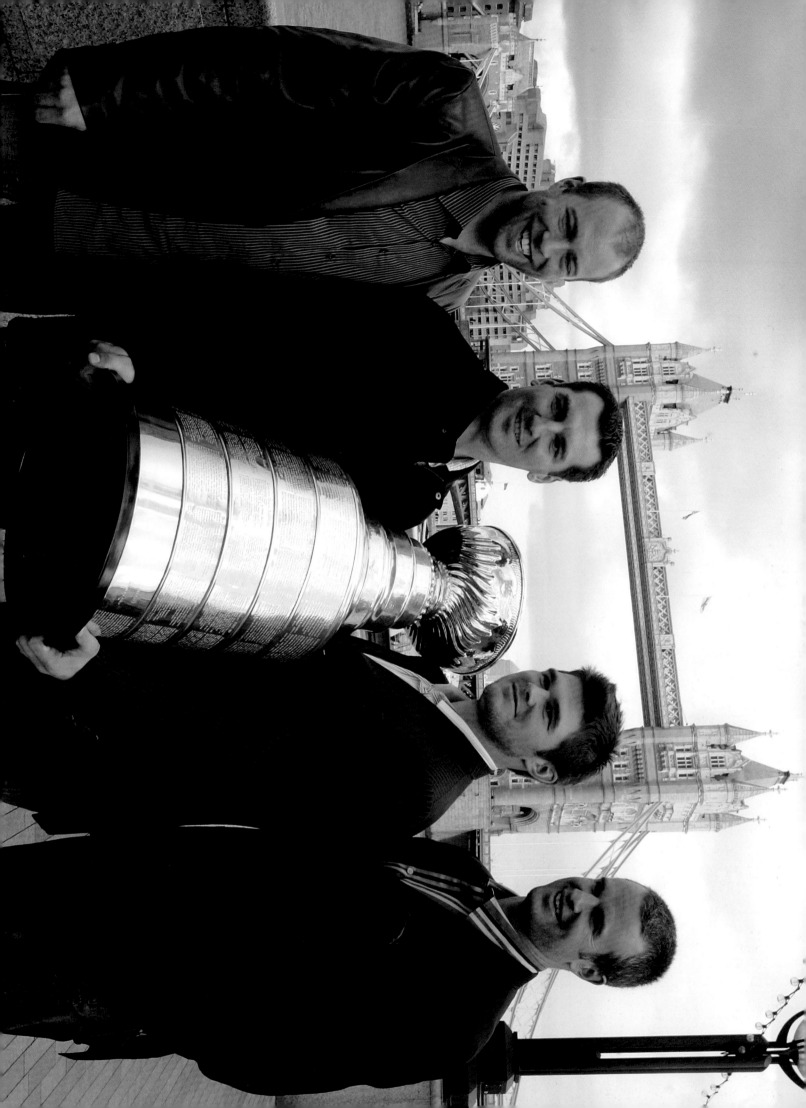

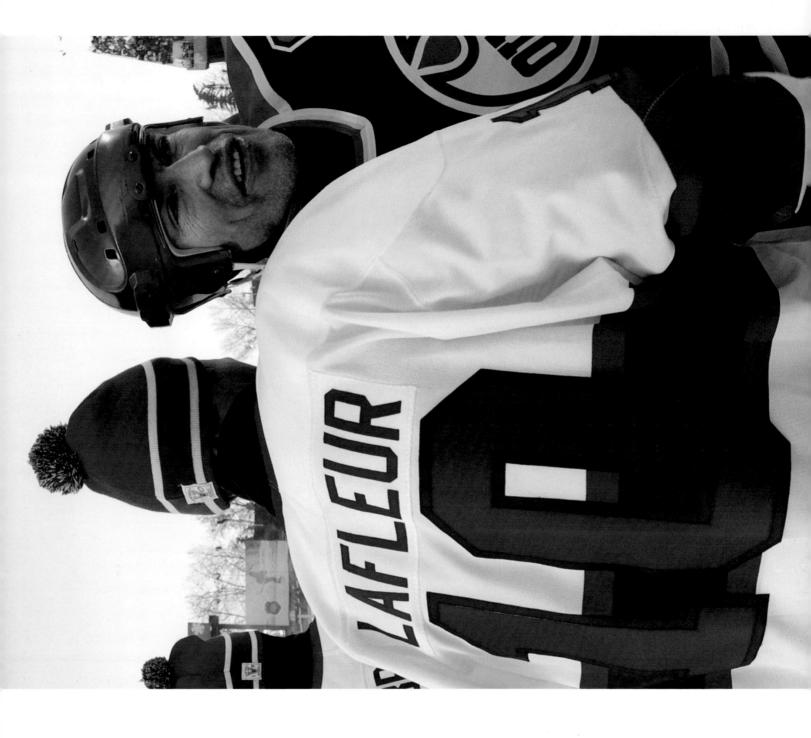

The Heritage Classic, played in Edmonton in 2003, recaptured the nostalgia we all feel for the game's more innocent times.

RIGHT: Legends Guy Lafleur and Mark Messier reminisce.

OPPOSITE PAGE: Habs' goaltender José Theodore tries to keep warm.

PP. 138–9: Mark Messier and Larry Robinson, Wayne Gretzky and Steve Shutt (Hall of Famers, all) remind us of their greatness while recapturing their youth—and ours.

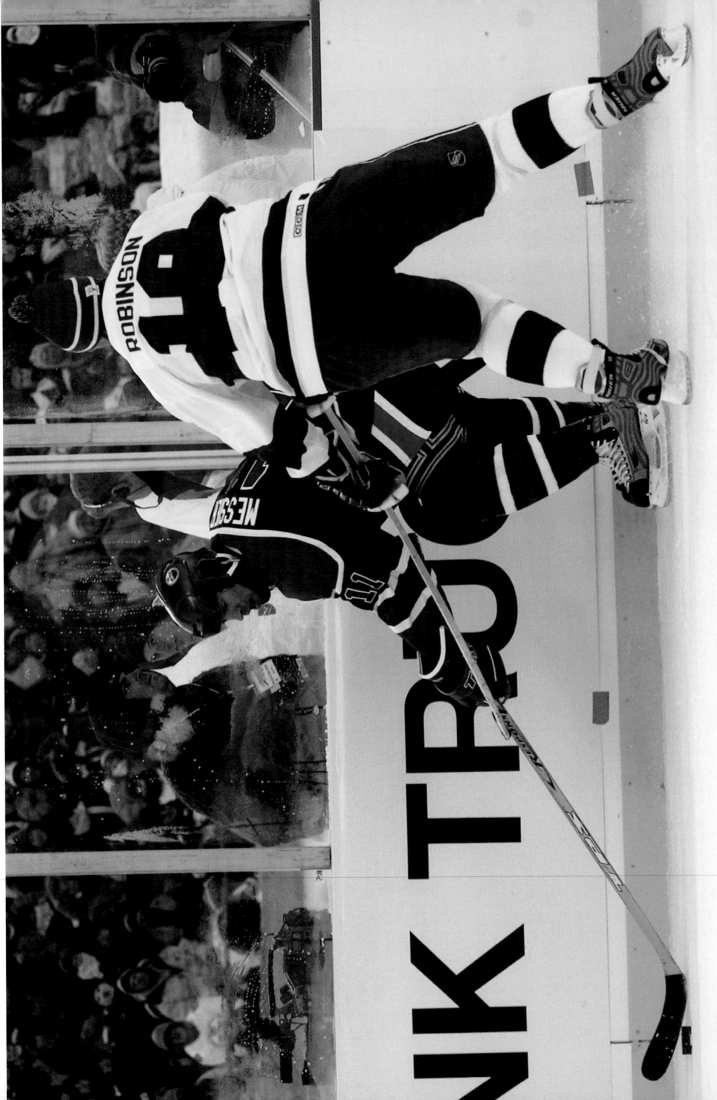

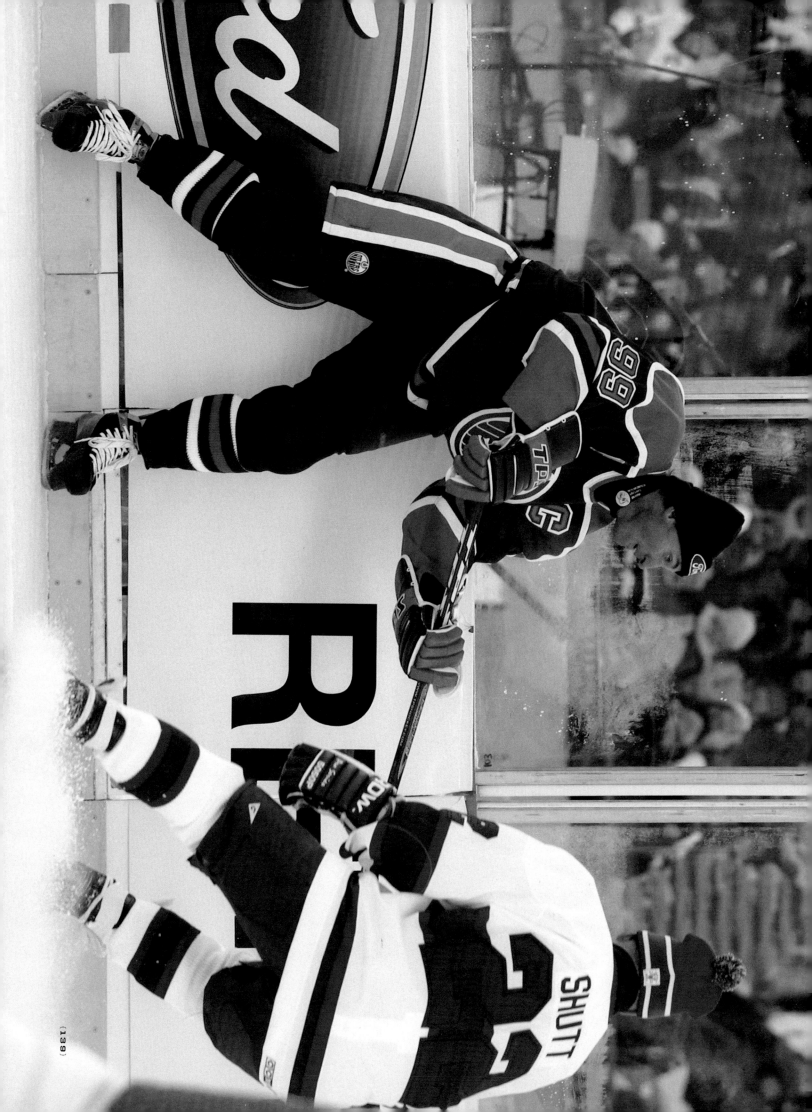

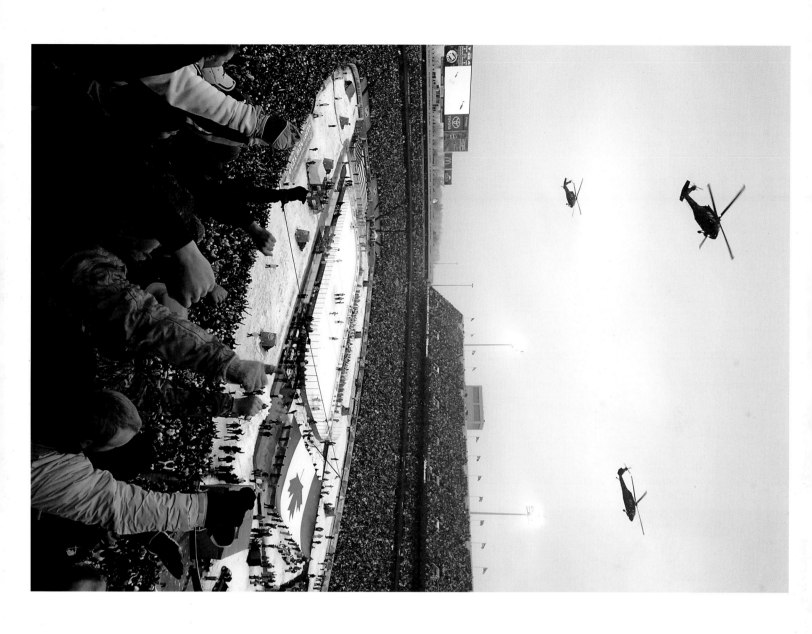

OPPOSITE PAGE: The stage is set at Ralph Wilson Stadium in Orchard Park, New York, in 2008 for the first of what would become the annual Winter Classics.

LEFT: Helicopters fly over Ralph Wilson Stadium following the national anthem.

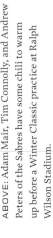

ABOVE: Adam Mair, Tim Connolly, and Andrew Peters of the Sabres have some chili to warm up before a Winter Classic practice at Ralph Wilson Stadium.

RIGHT: Pittsburgh star Sidney Crosby waves to the crowd after scoring the game-winning shootout goal in the 2008 Winter Classic.

OPPOSITE PAGE: Buffalo's netminder Ryan Miller braves the elements.

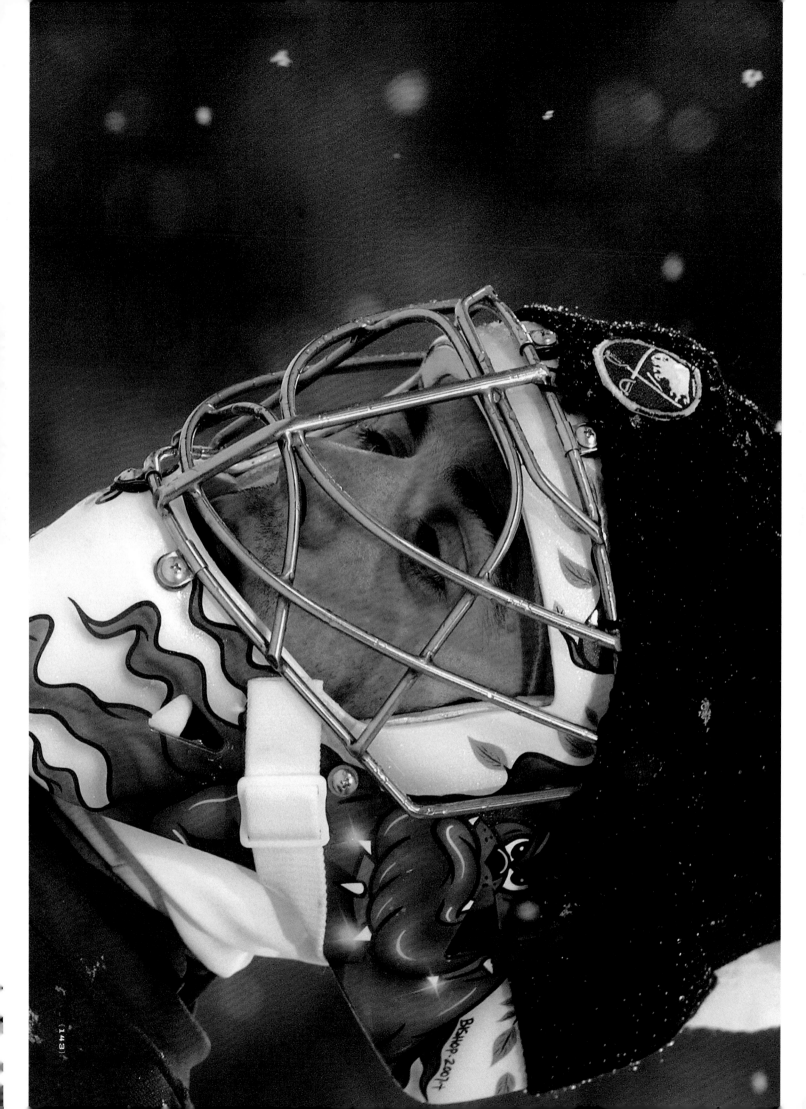

LEFT: In 2009, the "Friendly Confines" in Chicago played host to longtime rivals Chicago and Detroit in the second Winter Classic. Throwback sweaters added to the day's vintage feel.

P. 146: Andrew Ladd of the Blackhawks attempts a shot against Ty Conklin of the Red Wings.

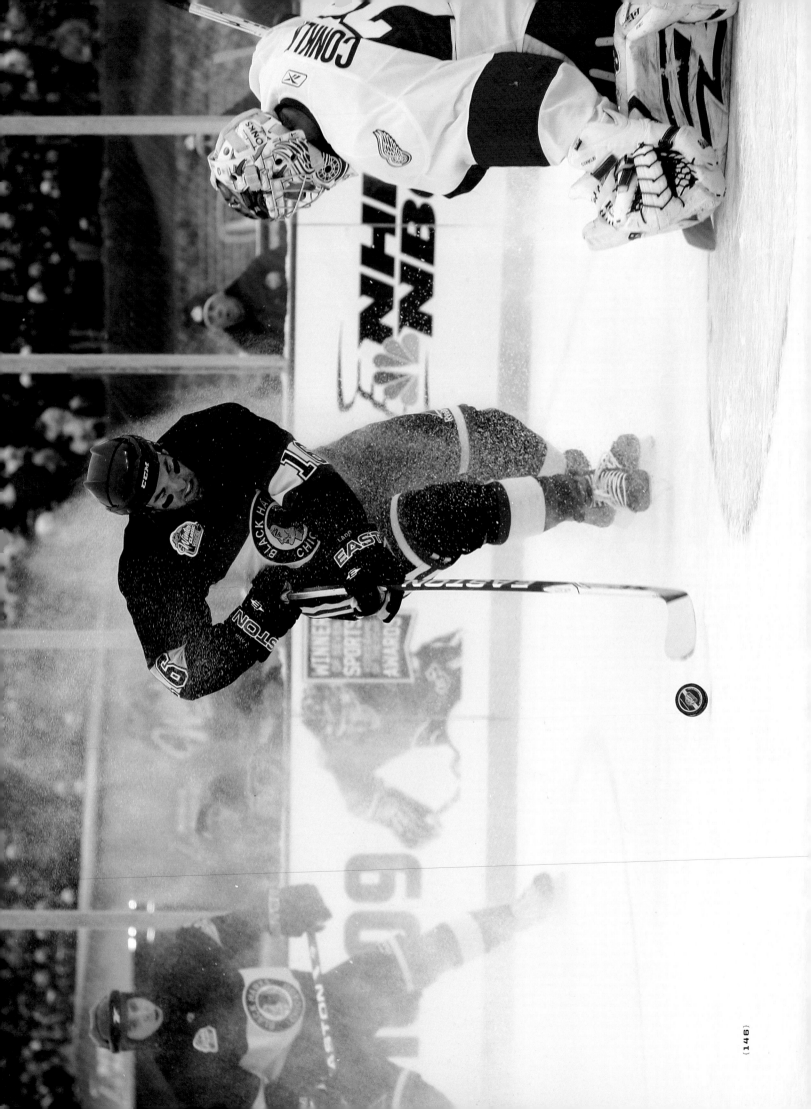

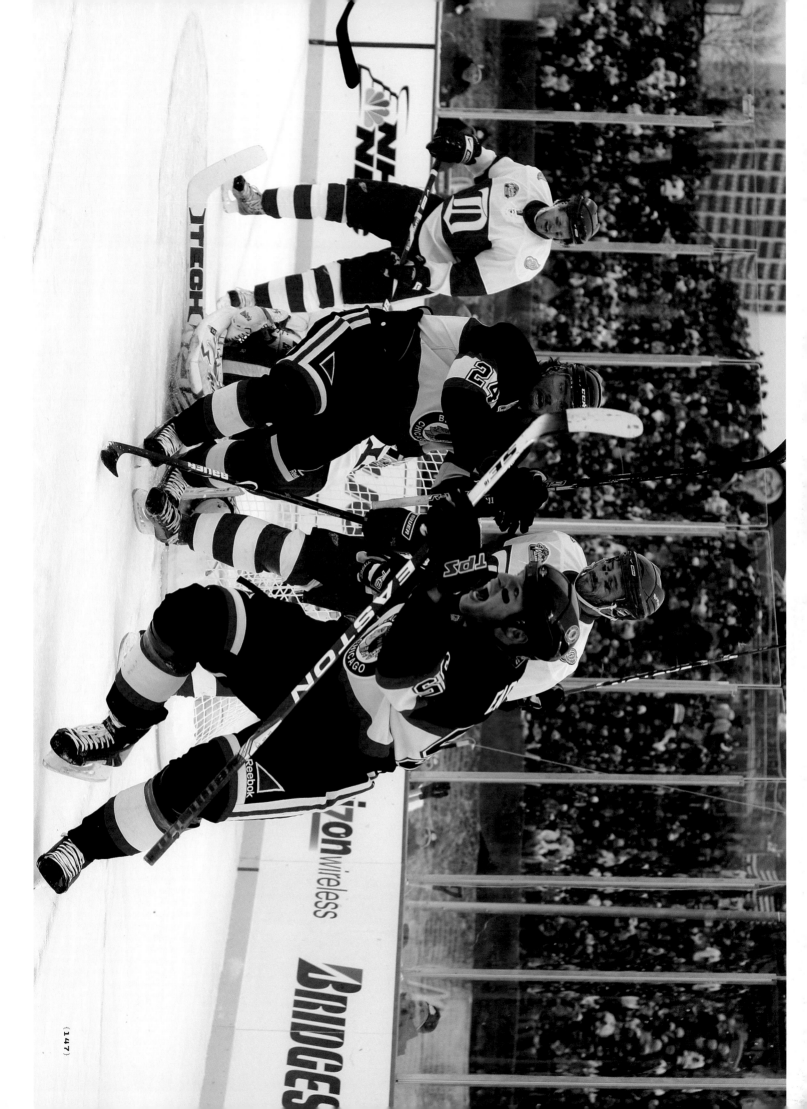

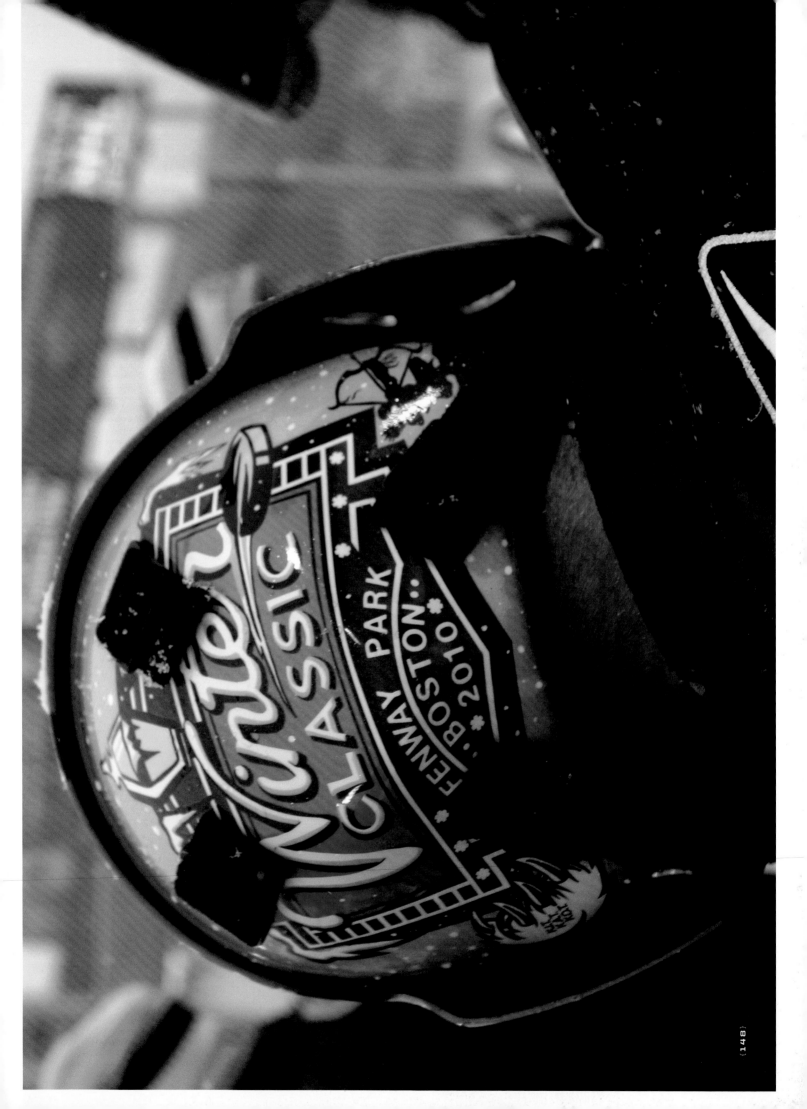

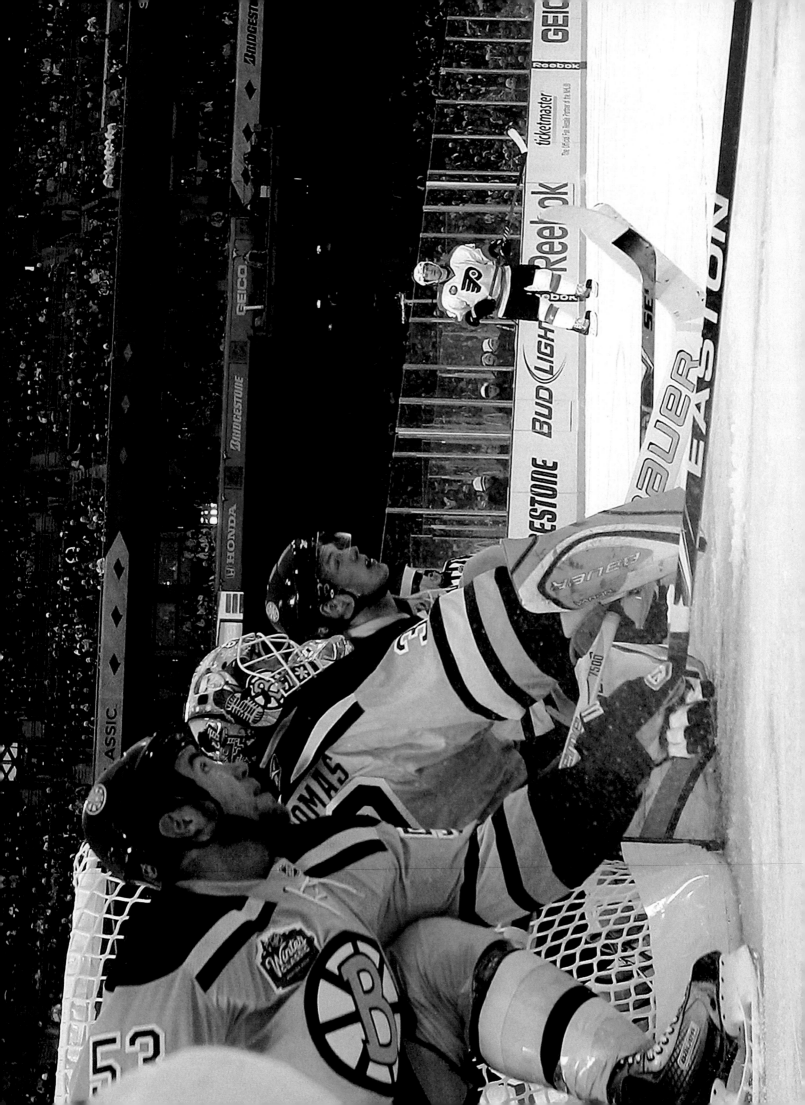

P. 147: Ben Eager celebrates scoring a goal in the great outdoors.

P. 148: A detail of the Winter Classic logo on the back of the mask worn by Boston's Tim Thomas.

P. 149: Boston's Claude Julien plays the part of the old-time, fedora-wearing head coach.

LEFT: Boston's Fenway Park has seen some historic hitting, but not of the like dished out in this 2010 Winter Classic meeting between Boston's Big, Bad Bruins and Philadelphia's Broad Street Bullies.

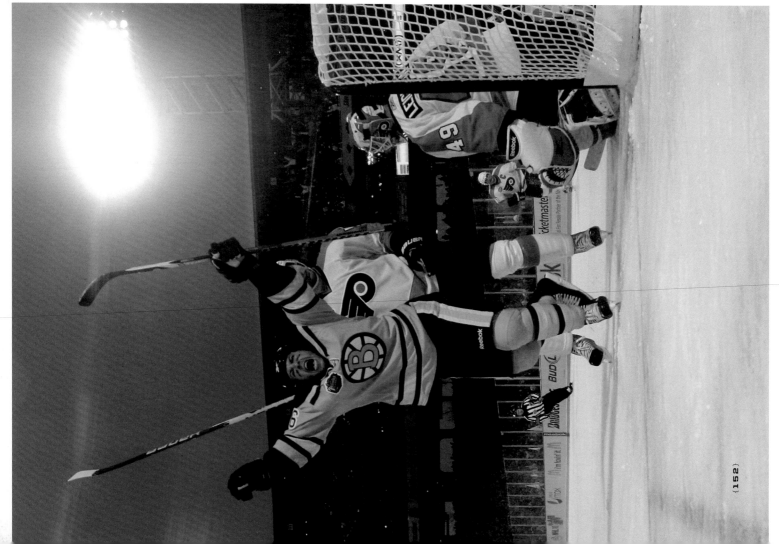

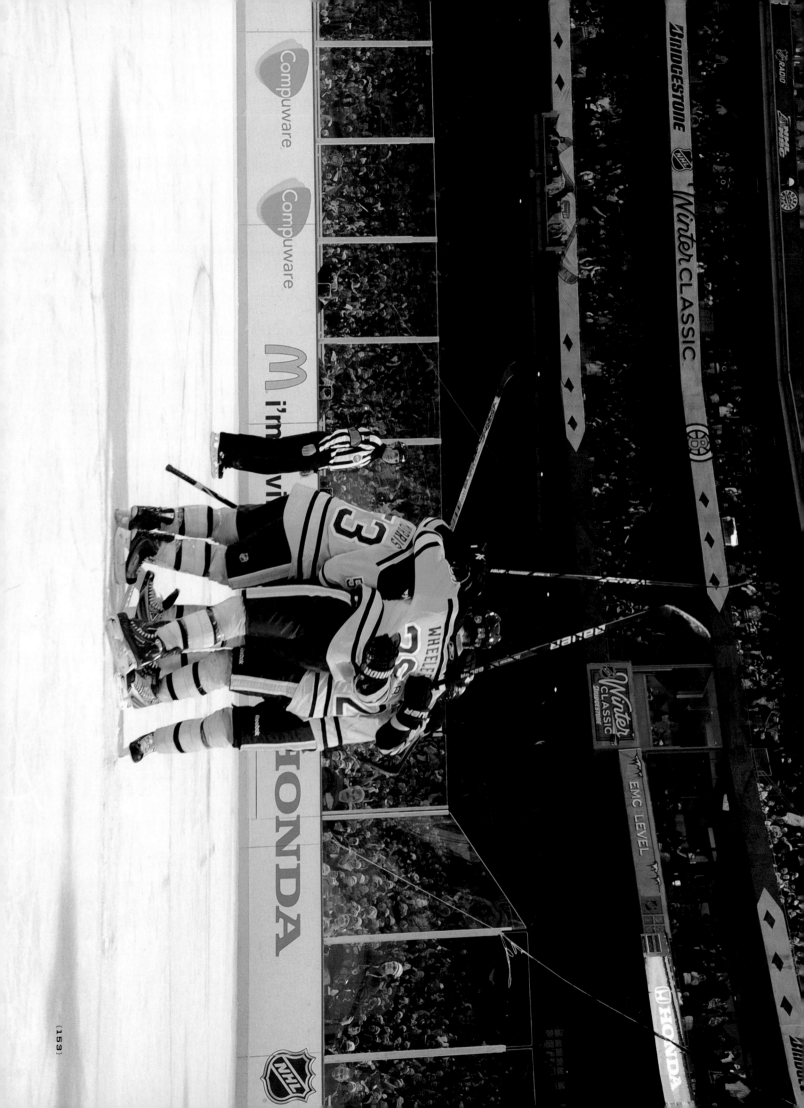

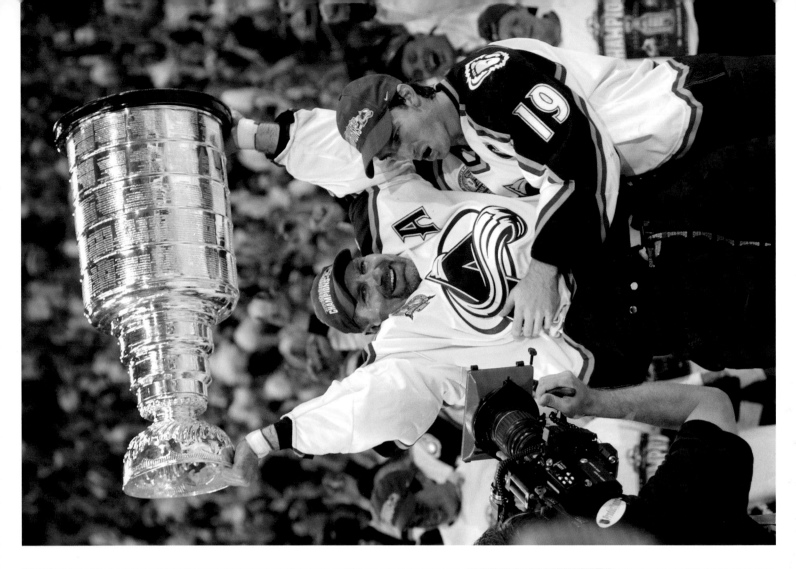

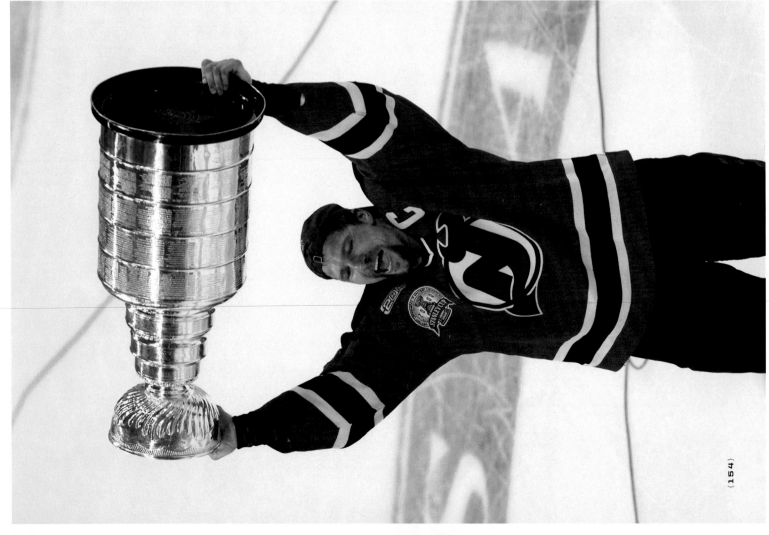

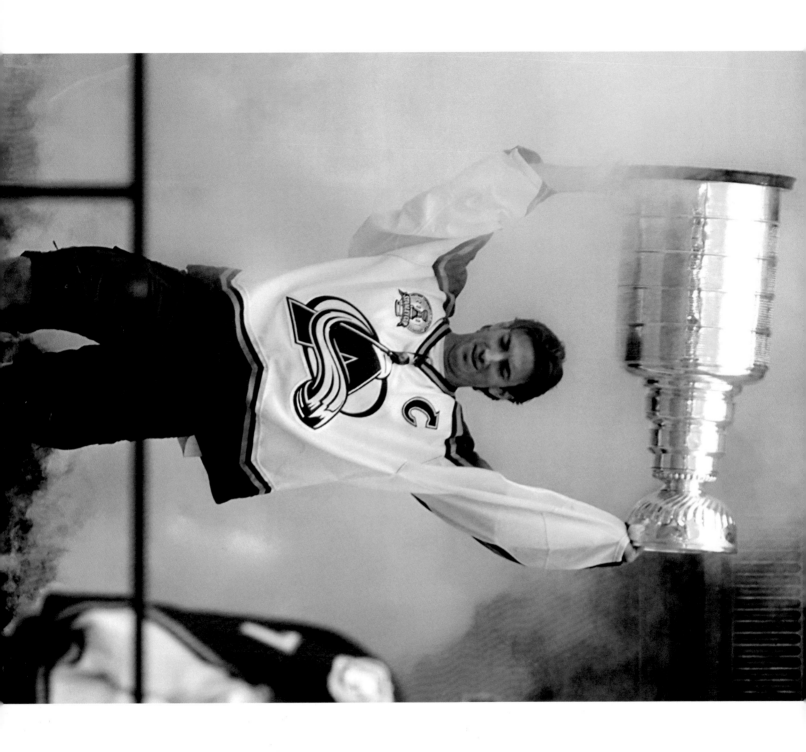

P. 152: Boston's Marco Sturm scores the Winter Classic–winning goal in overtime.

P. 153: The Bruins celebrate a goal.

OPPOSITE PAGE LEFT: New Jersey's Scott Stevens celebrates one of his three Stanley Cup championships.

OPPOSITE PAGE RIGHT: Colorado Avalanche captain Joe Sakic embraces defenseman Ray Bourque, who won his first—and only—Stanley Cup championship in 2001.

LEFT: Gentleman Joe shares the Cup with Colorado during a victory celebration.

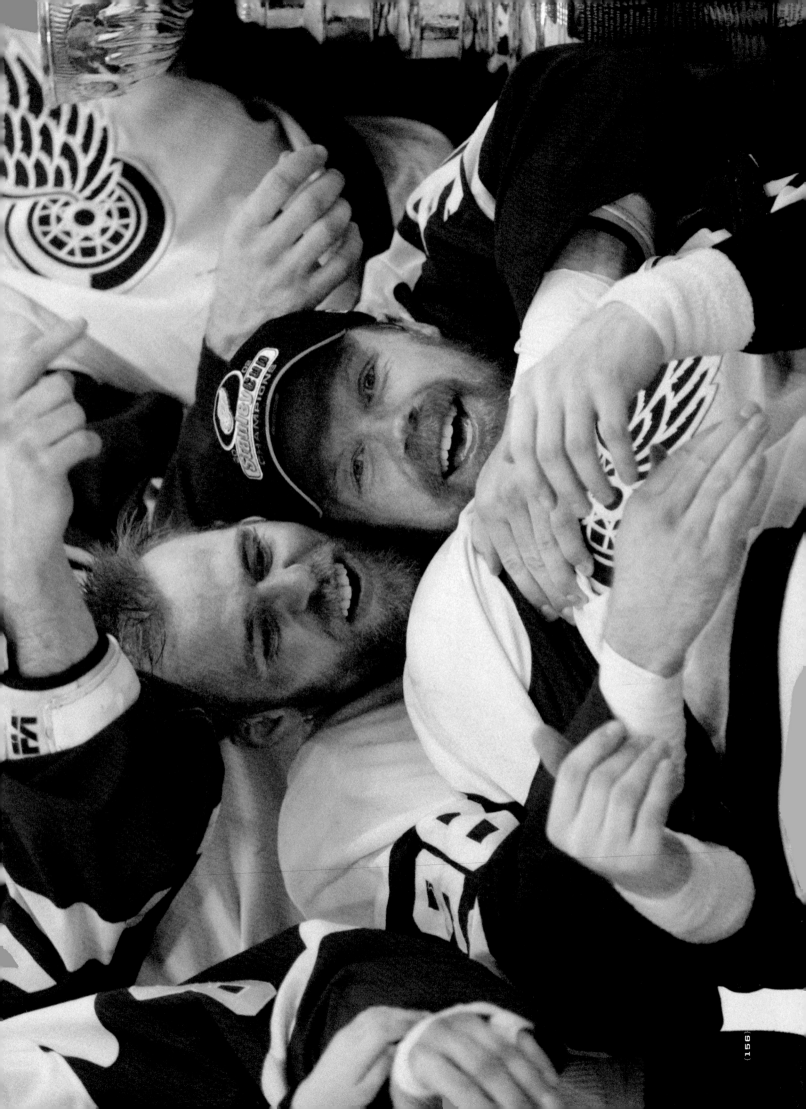

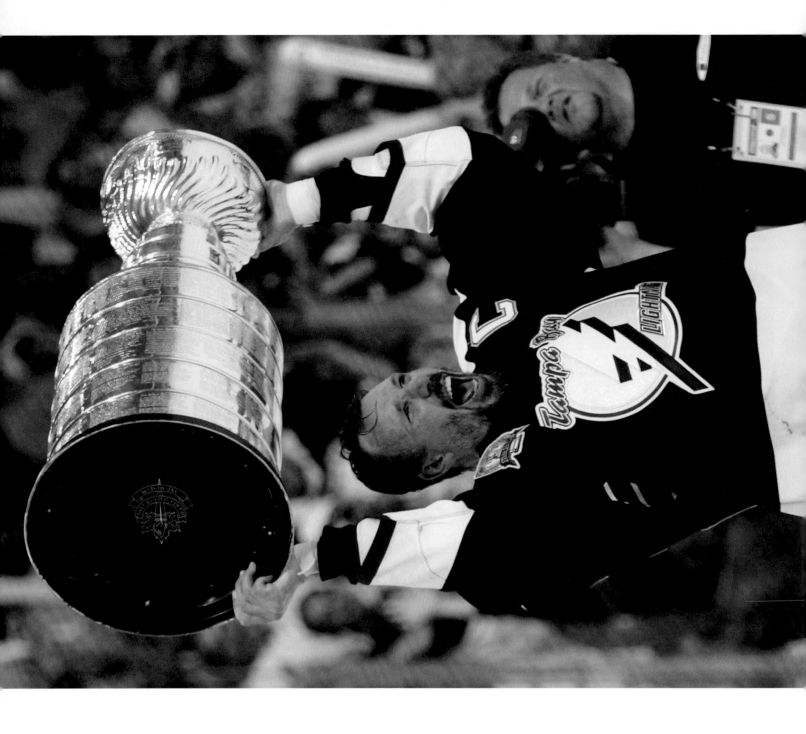

PP. 156–7: Of the 10 times the Stanley Cup has been awarded between 2000 and 2010, the Wings and Devils each won it twice; no other club has won it more than once during this period.

RIGHT: Tampa Bay's Dave Andreychuk celebrates his one and only Stanley Cup championship. The Lightning won the Cup in 2004, the season prior to the lockout.

OPPOSITE PAGE: With playoff beards at their fullest, Chris Dingman and Andre Roy of Tampa Bay rejoice after winning the Cup in 2004.

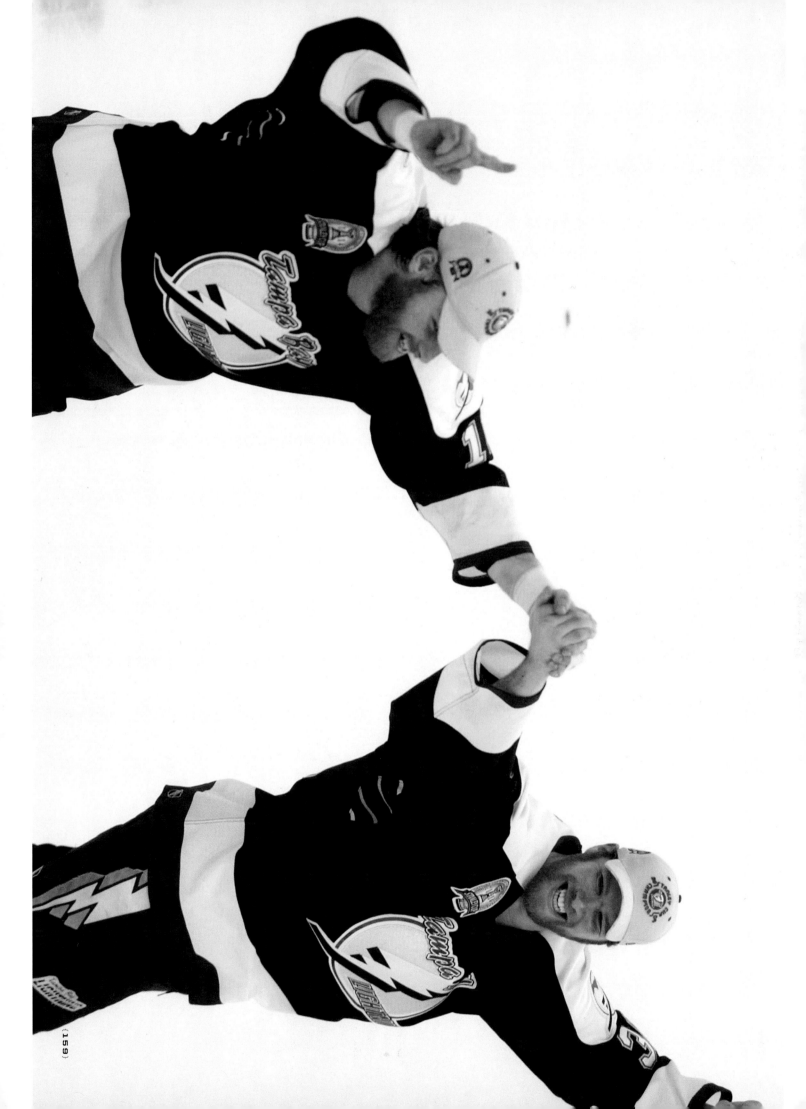

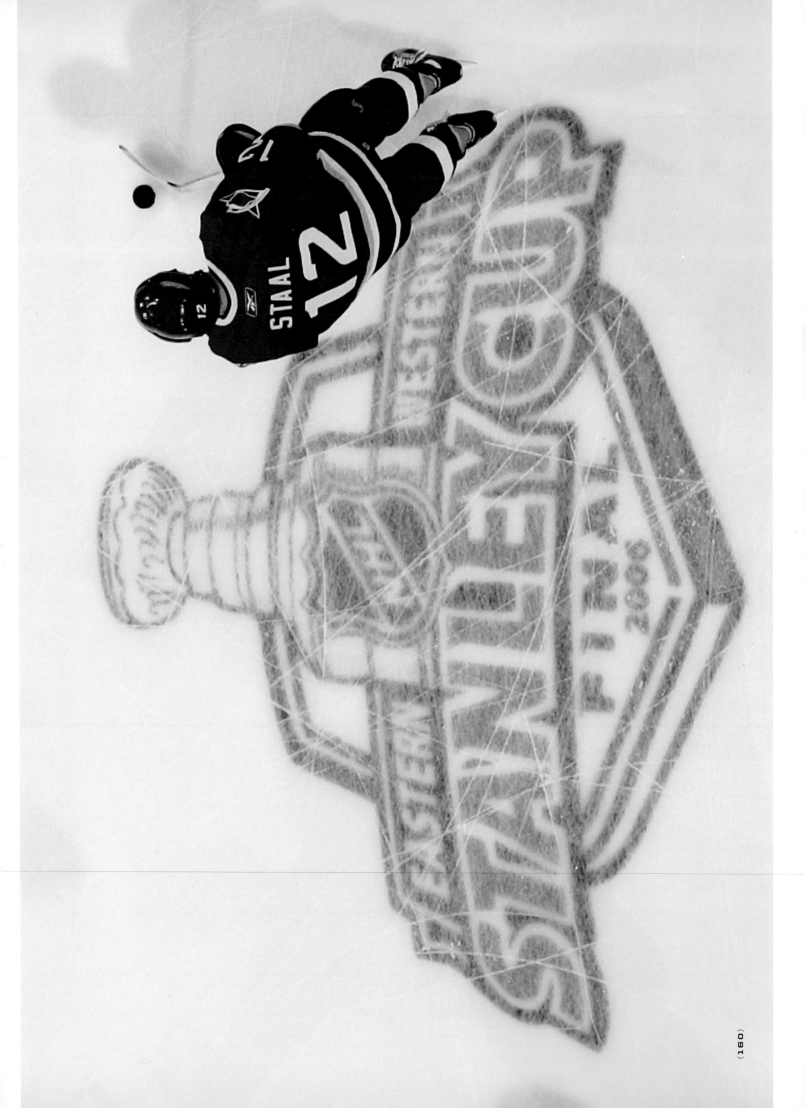

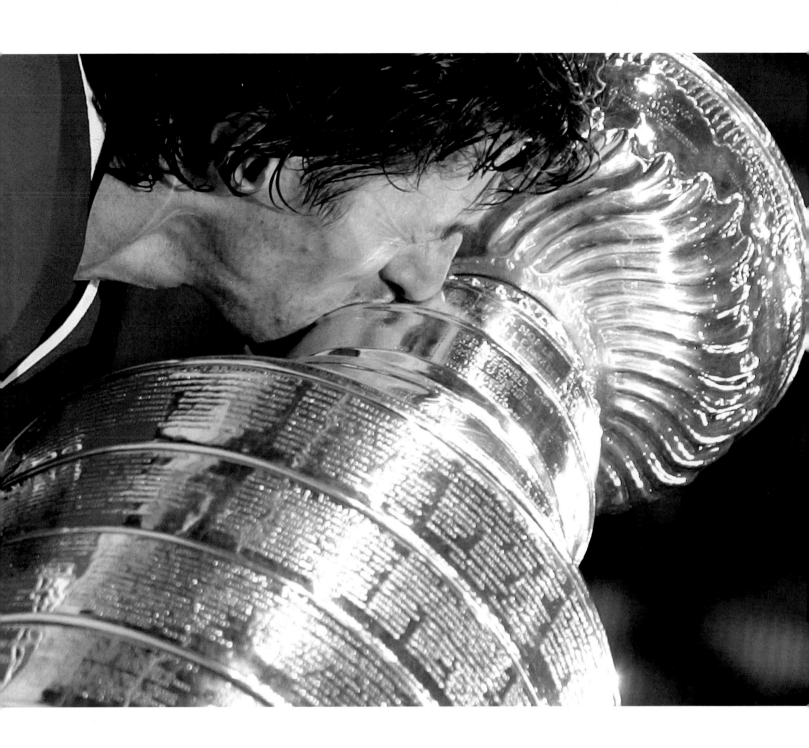

The Carolina Hurricanes, led by Rod Brind'amour (left) and featuring talented youngster Eric Staal (opposite), won the franchise's first Stanley Cup title in 2006. Here, Brind'amour (who retired in June following 21 NHL seasons) shows just what the Cup means to those who fight for it each spring.

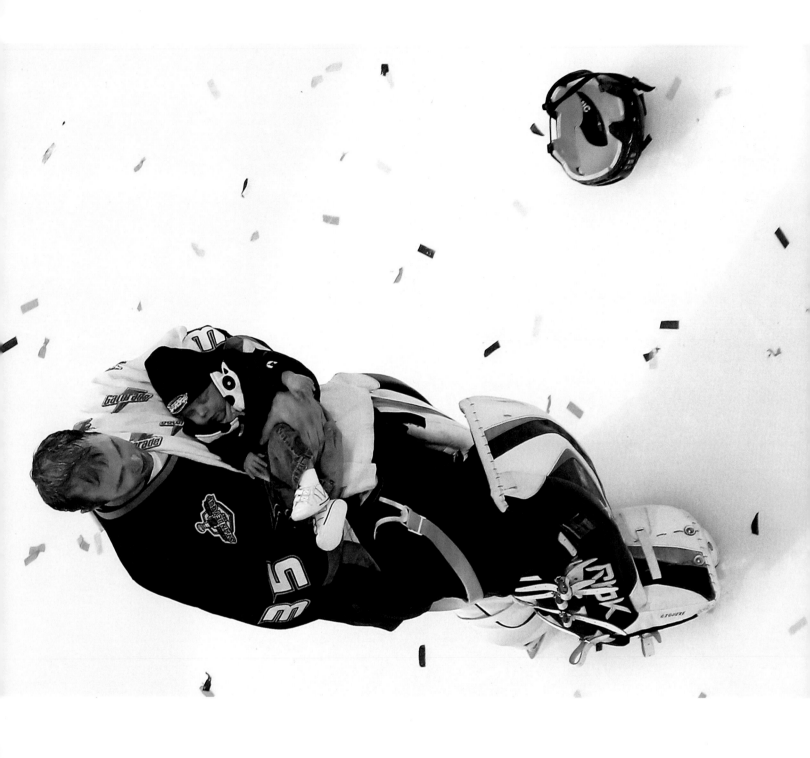

RIGHT: Goaltender J.S. Giguere shares the joy with his infant son in the aftermath of the Anaheim Ducks winning the 2007 Stanley Cup.

OPPOSITE PAGE LEFT: Brothers Rob and Scott Niedermayer live out the driveway dream of hockey-loving siblings everywhere: winning the Stanley Cup together.

OPPOSITE PAGE RIGHT: Detroit's Henrik Zetterberg hoists the Cup in 2008.

PP. 164–5: Mario Lemieux first led the Penguins to the Stanley Cup in 1991, when Sidney Crosby was four years old. By 2009, Crosby—already the youngest team captain in NHL history—became the youngest captain ever to hoist the Stanley Cup.

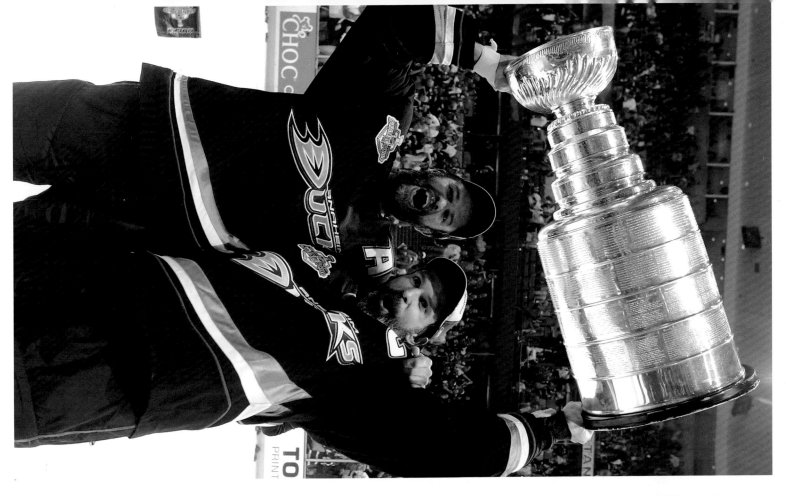

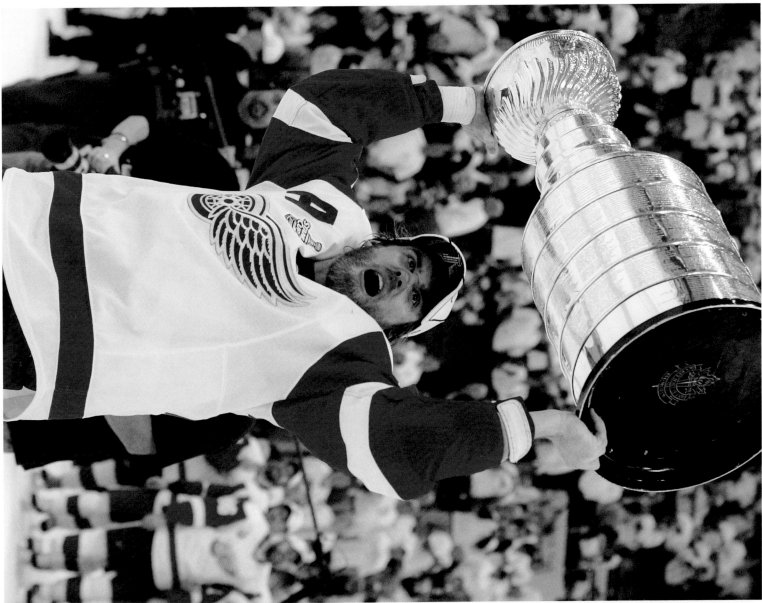

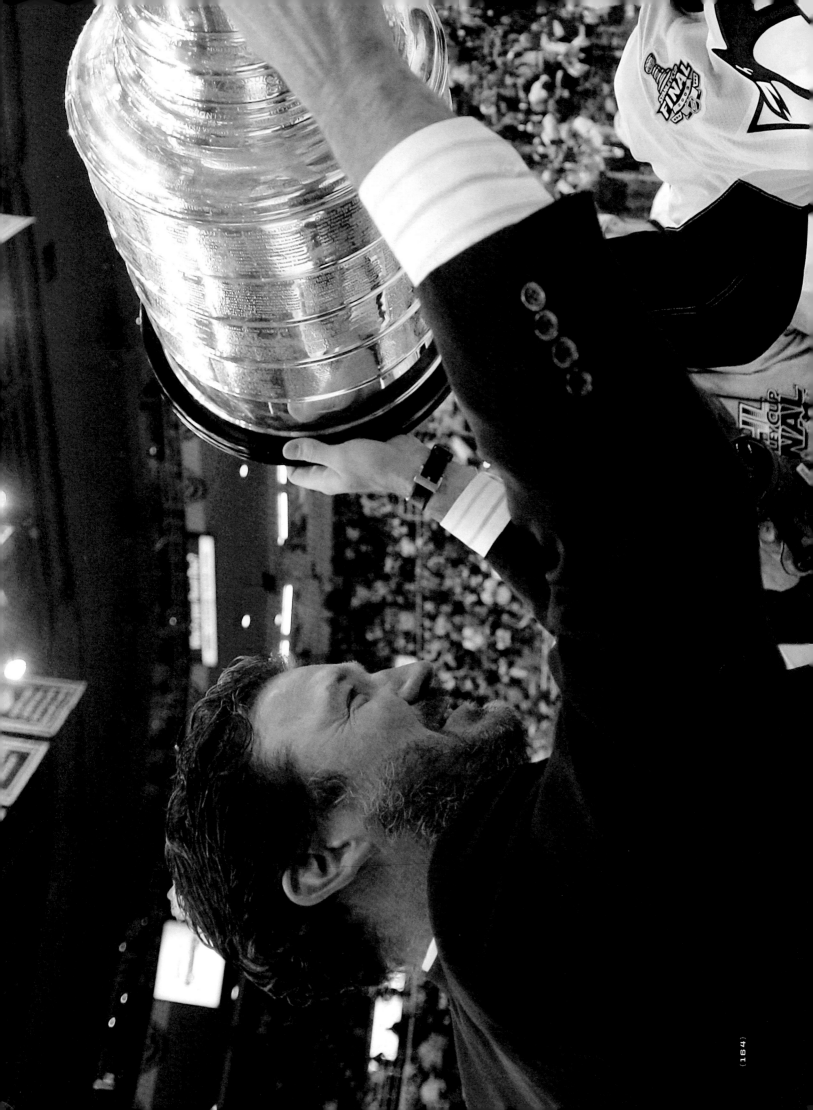

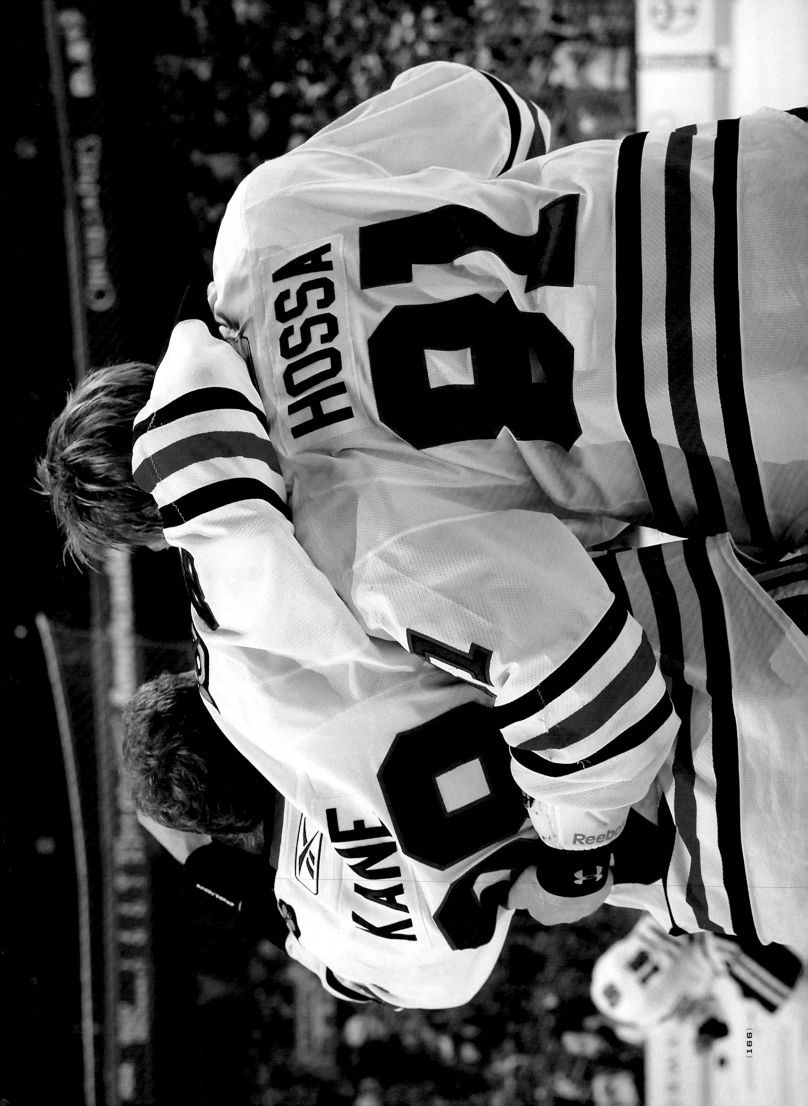

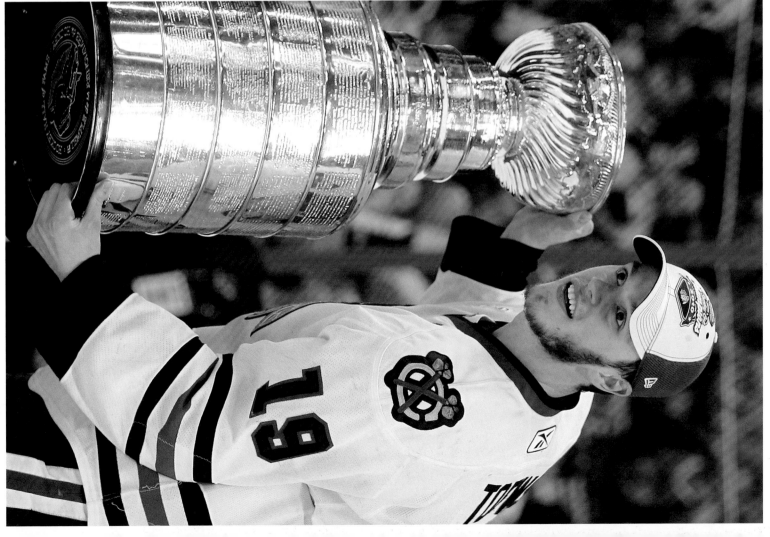

Ending a two-generation drought, the Chicago Blackhawks won the Stanley Cup in 2010. Rocky Wirtz (second from left, opposite) assumed control of the franchise following his father's death in 2007, and immediately set about restoring the Blackhawks to their former glory.

P. 166: Patrick Kane and Marian Hossa share a victorious moment.

P. 167 LEFT: Chicago power forward Dustin Byfuglien lifts the Cup.

P. 167 RIGHT: Blackhawks captain Jonathan Toews accepts the Cup for a franchise that hadn't hoisted the Cup since 1961.

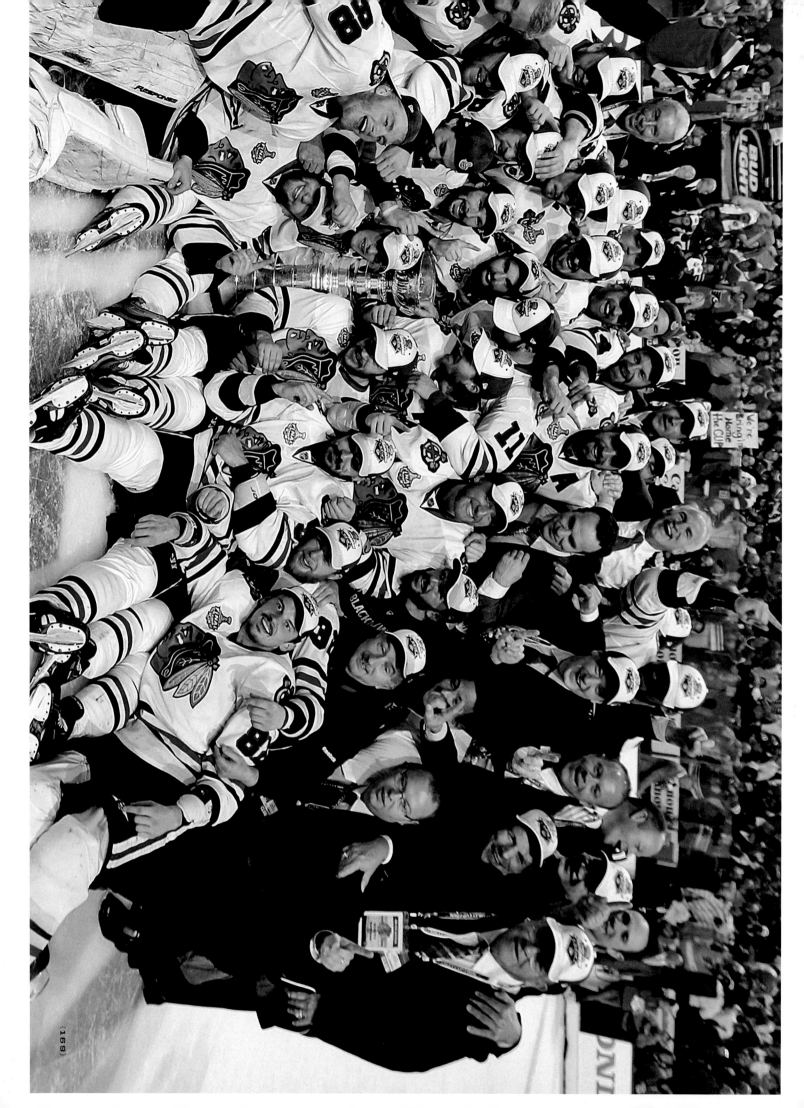

ACHIEVEMENTS AND HONOURS

STANLEY CUP FINAL

	WINNING TEAM	LOSING TEAM	GAMES
1999–2000	New Jersey Devils	Dallas Stars	4–2
2000–01	Colorado Avalanche	New Jersey	4–3
2001–02	Detroit Red Wings	Carolina Hurricanes	4–1
2002–03	New Jersey Devils	Anaheim Ducks	4–3
2003–04	Tampa Bay Lightning	Calgary Flames	4–3
2005–06	Carolina Hurricanes	Edmonton Oilers	4–3
2006–07	Anaheim Ducks	Ottawa Senators	4–1
2007–08	Detroit Red Wings	Pittsburgh Penguins	4–2
2008–09	Pittsburgh Penguins	Detroit Red Wings	4–3
2009–10	Chicago Blackhawks	Philadelphia Flyers	4–2

PRESIDENTS' TROPHY

BEST OVERALL RECORD:

1999–2000	St. Louis Blues
2000–01	Colorado Avalanche
2001–02	Detroit Red Wings
2002–03	Ottawa Senators
2003–04	Detroit Red Wings
2005–06	Detroit Red Wings
2006–07	Buffalo Sabres
2007–08	Detroit Red Wings
2008–09	San Jose Sharks
2009–10	Washington Capitals

ART ROSS TROPHY

TOP POINT SCORER:

1999–2000	Jaromir Jagr (PIT)
2000–01	Jaromir Jagr (PIT)
2001–02	Jarome Iginla (CGY)
2002–03	Peter Forsberg (COL)
2003–04	Martin St. Louis (TBL)
2005–06	Joe Thornton (BOS/SJS)
2006–07	Sidney Crosby (PIT)
2007–08	Alexander Ovechkin (WSH)
2008–09	Evgeni Malkin (PIT)
2009–10	Henrik Sedin (VAN)

BILL MASTERTON MEMORIAL TROPHY

QUALITIES OF PERSEVERANCE AND SPORTSMANSHIP:

1999–2000 Ken Daneyko (NJD)
2000–01 Adam Graves (NYR)
2001–02 Saku Koivu (MTL)
2002–03 Steve Yzerman (DET)
2003–04 Bryan Berard (CHI)
2005–06 Teemu Selanne (ANA)
2006–07 Phil Kessel (BOS)
2007–08 Jason Blake (TOR)
2008–09 Steve Sullivan (NSH)
2009–10 José Theodore (WSH)

CALDER MEMORIAL TROPHY

ROOKIE OF THE YEAR:

1999–2000 Scott Gomez (NJD)
2000–01 Evgeni Nabokov (SJS)
2001–02 Dany Heatley (ATL)
2002–03 Barret Jackman (STL)
2003–04 Andrew Raycroft (BOS)
2005–06 Alexander Ovechkin (WSH)
2006–07 Evgeni Malkin (PIT)
2007–08 Patrick Kane (CHI)
2008–09 Steve Mason (CBJ)
2009–10 Tyler Myers (BUF)

CONN SMYTHE TROPHY

MVP IN THE STANLEY CUP PLAYOFFS:

1999–2000 Scott Stevens (NJD)
2000–01 Patrick Roy (COL)
2001–02 Nicklas Lidstrom (DET)
2002–03 Jean-Sébastien Giguère (ANA)
2003–04 Brad Richards (TBL)
2005–06 Cam Ward (CAR)
2006–07 Scott Niedermayer (ANA)
2007–08 Henrik Zetterberg (DET)
2008–09 Evgeni Malkin (PIT)
2009–10 Jonathan Toews (CHI)

FRANK J. SELKE TROPHY

TOP DEFENSIVE FORWARD:

1999–2000 Steve Yzerman (DET)
2000–01 John Madden (NJD)
2001–02 Michael Peca (NYI)
2002–03 Jere Lehtinen (DAL)
2003–04 Kris Draper (DET)
2005–06 Rod Brind'Amour (CAR)
2006–07 Rod Brind'Amour (CAR)
2007–08 Pavel Datsyuk (DET)
2008–09 Pavel Datsyuk (DET)
2009–10 Pavel Datsyuk (DET)

HART MEMORIAL TROPHY

1999–2000 Chris Pronger (STL)
2000–01 Joe Sakic (COL)
2001–02 José Theodore (MTL)
2002–03 Peter Forsberg (COL)
2003–04 Martin St. Louis (TBL)
2005–06 Joe Thornton (BOS/SJS)
2006–07 Sidney Crosby (PIT)
2007–08 Alexander Ovechkin (WSH)
2008–09 Alexander Ovechkin (WSH)
2009–10 Henrik Sedin (VAN)

JAMES NORRIS MEMORIAL TROPHY

TOP DEFENSEMAN:

1999–2000 Chris Pronger (STL)
2000–01 Nicklas Lidstrom (DET)
2001–02 Nicklas Lidstrom (DET)
2002–03 Nicklas Lidstrom (DET)
2003–04 Scott Niedermayer (NJD)
2005–06 Nicklas Lidstrom (DET)
2006–07 Nicklas Lidstrom (DET)
2007–08 Nicklas Lidstrom (DET)
2008–09 Zdeno Chara (BOS)
2009–10 Duncan Keith (CHI)

JACK ADAMS AWARD

COACH OF THE YEAR:

1999–2000 Joel Quenneville (STL)
2000–01 Bill Barber (PHI)
2001–02 Bob Francis (PHX)
2002–03 Jacques Lemaire (MIN)
2003–04 John Tortorella (TBL)
2005–06 Lindy Ruff (BUF)
2006–07 Alain Vigneault (VAN)
2007–08 Bruce Boudreau (WSH)
2008–09 Claude Julien (BOS)
2009–10 Dave Tippett (PHX)

KING CLANCY MEMORIAL TROPHY

LEADERSHIP AND HUMANITARIAN CONTRIBUTION:

1999–2000 Curtis Joseph (TOR)
2000–01 Shjon Podein (COL)
2001–02 Ron Francis (CAR)

2007–08 Alexander Ovechkin (WSH)
2008–09 Alexander Ovechkin (WSH)
2009–10 Alexander Ovechkin (WSH)

WILLIAM JENNINGS TROPHY

GOALTENDER(S) WITH THE FEWEST GOALS SCORED AGAINST:

1999–2000 Roman Turek (STL)
2000–01 Dominik Hasek (BUF)
2001–02 Patrick Roy (COL)
2002–03 Martin Brodeur (NJD)
 Roman Cechmanek/Robert Esche (PHI)
2003–04 Martin Brodeur (NJD)
2005–06 Miikka Kiprusoff (CGY)
2006–07 Niklas Backstrom/Manny Fernandez (MIN)
2007–08 Dominik Hasek/Chris Osgood (DET)
2008–09 Tim Thomas/Manny Fernandez (MIN)
2009–10 Martin Brodeur (NJD)

NUMBER ONE DRAFT SELECTIONS:

2000 NEW YORK ISLANDERS: Rick DiPietro
2001 ATLANTA THRASHERS: Ilya Kovalchuk
2002 COLUMBUS BLUE JACKETS: Rick Nash
2003 PITTSBURGH PENGUINS: Marc-André Fleury
2004 WASHINGTON CAPITALS: Alexander Ovechkin
2005 PITTSBURGH PENGUINS: Sidney Crosby
2006 ST. LOUIS BLUES: Erik Johnson
2007 CHICAGO BLACKHAWKS: Patrick Kane
2008 TAMPA BAY LIGHTNING: Steven Stamkos
2009 NEW YORK ISLANDERS: John Tavares
2010 EDMONTON OILERS: Taylor Hall

MAURICE RICHARD TROPHY

TOP GOAL SCORER:

1999–2000 Pavel Bure (FLA)
2000–01 Pavel Bure (FLA)
2001–02 Jarome Iginla (CGY)
2002–03 Milan Hejduk (COL)
2003–04 Jarome Iginla (CGY)
 Ilya Kovalchuk (ATL)
 Rick Nash (CBJ)
2005–06 Jonathan Cheechoo (SJS)
2006–07 Vincent Lecavalier (TBL)
2007–08 Alexander Ovechkin (WSH)
2008–09 Alexander Ovechkin (WSH)
2009–10 Sidney Crosby (PIT)
 Steven Stamkos (TBL)

VEZINA TROPHY

TOP GOALTENDER:

1999–2000 Olaf Kolzig (WSH)
2000–01 Dominik Hasek (BUF)
2001–02 Jose Theodore (MTL)
2002–03 Martin Brodeur (NJD)
2003–04 Martin Brodeur (NJD)
2005–06 Miikka Kiprusoff (CGY)
2006–07 Martin Brodeur (NJD)
2007–08 Martin Brodeur (NJD)
2008–09 Tim Thomas (BOS)
2009–10 Ryan Miller (BUF)

2002–03 Brendan Shanahan (DET)
2003–04 Jarome Iginla (CGY)
2005–06 Olaf Kolzig (WSH)
2006–07 Saku Koivu (MTL)
2007–08 Vincent Lecavalier (TBL)
2008–09 Ethan Moreau (EDM)
2009–10 Shane Doan (PHX)

LADY BYNG MEMORIAL TROPHY

PLAYER WHO DISPLAYS GENTLEMANLY CONDUCT:

1999–2000 Pavol Demitra (STL)
2000–01 Joe Sakic (COL)
2001–02 Ron Francis (CAR)
2002–03 Alexander Mogilny (TOR)
2003–04 Brad Richards (TBL)
2005–06 Pavel Datsyuk (DET)
2006–07 Pavel Datsyuk (DET)
2007–08 Pavel Datsyuk (DET)
2008–09 Pavel Datsyuk (DET)
2009–10 Martin St. Louis (TBL)

TED LINDSAY AWARD (FORMERLY LESTER B. PEARSON AWARD)

MOST OUTSTANDING PLAYER AS SELECTED BY THE NHLPA:

1999–2000 Jaromir Jagr (PIT)
2000–01 Joe Sakic (COL)
2001–02 Jarome Iginla (CGY)
2002–03 Markus Naslund (VAN)
2003–04 Martin St. Louis (TBL)
2005–06 Jaromir Jagr (NYR)
2006–07 Sidney Crosby (PIT)

All photographs by NHL
Images and Getty Images.

2 8721396 4
 13 May 2009
 By: Mitchell Layton

5 9827074 8
 2 Apr 2010
 By: Jim McIsaac

6 7773344 2
 10 Oct 2007
 By: Jim McIsaac

8 7312696 8
 3 Jan 2007
 By: Jeff Vinnick

13 278376 8
 22 Nov 2003
 By: Dave Sandford

16 1088168 5
 4 Jun 2010
 By: Len Redkoles

24–5 5093724 1
 7 Jun 2004
 By: Doug Benc

26 8372521 3
 15 Nov 2008
 By: Jeff Vinnick

27 984622 9
 14 Apr 2010
 By: Christian Petersen

28 5090995 3
 29 May 2004
 By: Brian Bahr

29 7783373 2
 9 Nov 2007
 By: Eliot J. Schechter

30 8426274 9
 12 Jan 2009
 By: Bruce Bennett

31 7107555 1
 28 May 2006
 By: Grant Halverson

32 8471318 8
 25 Jan 2009
 By: Dave Sandford

33 left 8029723 9
 7 Feb 2008
 By: Jeff Vinnick

33 right 9179653 5
 10 Oct 2009
 By: Steve Babineau

34 7406706 4
 3 May 2007
 By: Jeff Vinnick

35 8343374 5
 25 Oct 2008
 By: Bill Smith

36 9635017 5
 31 Jan 2010
 By: Eliot J. Schechter

37 7287849 7
 26 Dec 2006
 By: Jon Greenberg

38 left 7212773 6
 9 Oct 2006
 By: Dale MacMillan

38 right 9866434 6
 25 Apr 2010
 By: Stephen Dunn

39 8108926 3
 14 May 2008
 By: Christian Petersen

40 8575457 6
 31 Mar 2009
 By: Eliot J. Schechter

41 8031370 7
 7 Mar 2008
 By: Dale MacMillan

42 985617 3
 19 Apr 2010
 By: Andrew D. Bernstein

43 left 8354257 7
 30 Oct 2008
 By: Bill Wippert

43 right 199369 3
 27 Dec 2002
 By: Brian Bahr

44 7264084 9
 24 Nov 2006
 By: Marc Serota

45 8439998 6
 21 Jan 2009
 By: Gerry Thomas

46 9632831 0
 26 Jan 2010
 By: Dave Sandford

47 57122 0
 18 May 2002
 By: Dave Sandford

48 5230498 5
 1 Jan 2004
 By: B Bennett

49 left 8023073 2
 10 Mar 2008
 By: Kevin Hoffman

49 right 52486 9
 4 May 2002
 By: Tom Pidgeon

50 5230571 6
 1 Jan 2003
 By: B Bennett

51 65524 6
 14 Dec 2000
 By: Kellie Landis

52 7249462 7
 16 Apr 2000
 By: Ian Tomlinson

53 5734473 8
 15 Apr 2006
 By: Noah Graham

54 287120 7
 2 Dec 2003
 By: Dave Sandford

55 164576 9
 26 Oct 2002
 By: Dave Sandford

56 left 2620451
 18 Sep 2003
 By: Dave Sandford

56 right 7751108 3
 20 Oct 2007
 By: Mark Buckner

57 5235204 6
 1 Jan 2004
 By: B Bennett

58 65827 2
 31 May 2002
 By: Tom Pidgeon

59 left 58070 8
 26 Jun 2001
 By: Brian Bahr

59 right 5231510 6
 1 Jan 2003
 By: B Bennett

60 5587363 9
 5 Oct 2005
 By: Bruce Bennett

61 7295541 0
 26 Dec 2005
 By: Don Smith

62 8354258 6
 30 Oct 2008
 By: Bill Wippert

63 9850678 5
 10 Apr 2010
 By: John Russell

64 5597490 5
 5 Oct 2005
 By: Dave Sandford

65 left 5716934 7
 23 Mar 2006
 By: Jeff Vinnick

65 right 9621176 6
 26 Jan 2010
 By: Jamie Sabau

66 80003119
28 Feb 2008
By: Len Redkoles

67 52346008
1 Jan 2003
By: B Bennett

68 96397594
3 Feb 2010
By: Rick Stewart

69 80261815
15 Mar 2008
By: Dave Reginek

70 56240314
10 Nov 2005
By: Dave Sandford

71 1419738
23 Apr 2002
By: Al Bello

72–3 55731172
20 Sep 2005
By: Bruce Bennett

74 *left* 101675512
6 Jun 10
By: Bruce Bennett

74 *right* 102108262
6 Jun 10
By: Jim McIsaac

75 7344356
27 Feb 2007
By: Andy Marlin

76 57543592
5 May 2006
By: Robert Laberge

77 97921746
17 Mar 2010
By: Bruce Bennett

78 *left* 98336236
8 Apr 2010
By: Ronald Martinez

78 *right* 98224438
2 Apr 2010
By: Debora Robinson

79 98224359
2 Apr 2010
By: Jeff Gross

80 9827316
5 Apr 2010
By: Andy Devlin

81 98384104
10 Apr 2010
By: Bruce Kluckhohn

82 92885691
7 Nov 2009
By: Al Bello

83 95650919
6 Jan 2010
By: Len Redkoles

84 78179715
7 Nov 2007
By: Jed Jacobsohn

85 80072844
2 May 2008
By: Christian Petersen

86 71297525
19 Jun 2006
By: Jim McIsaac

87 71207410
14 Jun 2006
By: Bruce Bennett

88 95595202
5 Jan 2010
By: Gregory Shamus

89 98381459
10 Apr 2010
By: Kevin C. Cox

90 98067986
13 Feb 2010
By: Jonathan Daniel

91 98148860
29 Mar 2010
By: Brian Babineau

92 80023478
29 Apr 2008
By: Ronald Martinez

93 632431
24 Apr 2002
By: Harry How

94 85136321
26 Feb 2009
By: Andy Devlin

95 85413397
1 Mar 2009
By: Jeff Vinnick

96 57580730
10 May 2006
By: Bruce Bennett

97 94996160
21 Dec 2009
By: Gregory Shamus

98 98398912
11 Apr 2010
By: Eliot J. Schechter

99 *left* 73561289
11 Mar 2007
By: Bruce Kluckhohn

99 *right* 50937278
7 Jun 2004
By: Dave Sandford

100 98335989
8 Apr 2010
By: Eliot J. Schechter

101 96199220
26 Jan 2010
By: Gregory Shamus

102 84571568
31 Jan 2009
By: Andre Ringuette

103 79846202
19 Feb 2008
By: Dave Sandford

104 *left* 96304127
31 Jan 2010
By: Ronald Martinez

104 *right* 98816742
25 Apr 2010
By: Dave Reginek

105 80356103
20 Mar 2008
By: Norm Hall

106 98698690
25 Apr 2010
By: Noah Graham

107 99037155
11 May 2010
By: Jeff Vinnick

108 98248850
4 Apr 2010
By: Jeff Vinnick

109 77500999
13 Oct 2007
By: Jeff Vinnick

110 *left* 97923028
20 Mar 2010
By: Jim McIsaac

110 *right* 98873081
5 May 2010
By: Len Redkoles

111 72811974
12 Dec 2006
By: Eliot J. Schechter

112 96483140
7 Feb 2010
By: Mitchell Layton

113 72505403
10 Nov 2006
By: Rick Stewart

114 *left* 84169029
4 Jan 2009
By: Bill Smith

114 *right* 50904569
27 May 2004
By: Dave Sandford

115 86468548
4 May 2009
By: Len Redkoles

116 50937217
7 Jun 2004
By: Elsa

117 56736307
2 Feb 2006
By: Jim McIsaac

118 88195229
21 May 2009
By: Jamie Sabau

119 84788961
13 Feb 2009
By: Jamie Sabau

120 98674215
23 Apr 2010
By: Bill Wippert

121 79420569
30 Jan 2008
By: Gerry Thomas

122–3 97709205
2 Mar 2010
By: Jim McIsaac

124 98295127
6 Apr 2010
By: Bill Wippert

125 98270636
2 Apr 2010
By: Jim McIsaac

126 292852
16 Dec 2003
By: Dave Sandford

127 56279269
26 Nov 2005
By: Scott Cunningham

128–9 72900201
13 Dec 2006
By: Doug Pensinger

130 83288246
15 Oct 2008
By: Andre Ringuette

131 84014516
4 Dec 2008
By: Andre Ringuette

132 83918754
4 Dec 2008
By: Andre Ringuette

133 77053432
26 Sep 2007
By: Bruce Bennett

134 77108820
29 Sep 2007
By: Daniel Berehulak

135 79283492
27 Jan 2008
By: Kevin C. Cox

136 2812477
22 Nov 2003
By: Dave Sandford

137 2784120
22 Nov 2003
By: Jeff Vinnick

138 2754524
22 Nov 2003
By: Dave Sandford

139 2812385
22 Nov 2003
By: Dave Sandford

140 78678606
30 Dec 2007
By: Rick Stewart

141 78668963
1 Jan 2008
By: Rick Stewart

142 *left* 78682629
31 Dec 2007
By: Bill Wippert

142 *right* 78689697
1 Jan 2008
By: Dave Sandford

143 78690878
1 Jan 2008
By: Dave Sandford

144–5 8454531
31 Dec 2008
By: AJ Messier

146 8455046
1 Jan 2009
By: Jamie Squire

147 8455052
1 Jan 2009
By: Jamie Squire

148 9551853
31 Dec 2009
By: Dave Sandford

149 95553325
1 Jan 2010
By: Elsa

150–1 95566127
1 Jan 2010
By: Jim McIsaac

152 95522672
1 Jan 2010
By: Dave Sandford

153 95522553
1 Jan 2010
By: Brian Babineau

154 *left* 548354
10 Jun 2000
By: Brian Bahr

154 *right* 580213
9 Jun 2001
By: Elsa

155 586032
11 Jun 2001
By: Brian Bahr

156 762780
13 Jun 2002
By: Elsa

157 *left* 791238
13 Jun 2002
By: Elsa

157 *right* 2090246
9 Jun 2003
By: Brian Bahr

158 50937508
7 Jun 2004
By: Elsa

159 50937680
7 Jun 2004
By: Jeff Gross

160 71297561
19 Jun 2006
By: Jim McIsaac

161 72949744
19 Jun 2006
By: Jim McIsaac

162 74427498
6 Jun 2007
By: Jeff Golden

163 *left* 74427266
6 Jun 2007
By: Dave Sandford

163 *right* 81777588
4 Jun 2008
By: Bruce Bennett

164 88486904
12 Jun 2009
By: Dave Sandford

165 88605597
12 Jun 2009
By: Bruce Bennett

166 102074397
9 Jun 2010
By: Len Redkoles

167 *left* 102074078
9 Jun 2010
By: Len Redkoles

167 *right* 102099328
9 Jun 2010
By: Bruce Bennett

168–9 10207324
9 Jun 2010
By: Len Redkoles

TAKE HOME A PIECE OF NHL HISTORY

BUY FRAMED NHL PRINTS, FEATURING INCREDIBLE ACTION PHOTOS

FROM YOUR FAVOURITE TEAM AND PLAYERS

20% OFF ANY PRINT

Hurry, this offer ends soon!

Order at **NHL.COM/PHOTOSTORE** today

for 20% off any NHL PhotoStore print

ENTER COUPON CODE:

REFLECTIONS2010

AT CHECKOUT

NHL PHOTOSTORE